Reclamation and Transformation:
Three Self-Taught Chicago Artists

David Philpot, Mr. Imagination, Kevin Orth

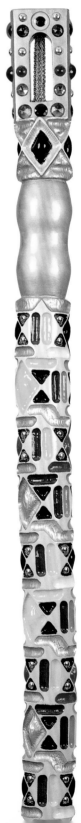

Reclamation and Transformation:

Three Self-Taught Chicago Artists

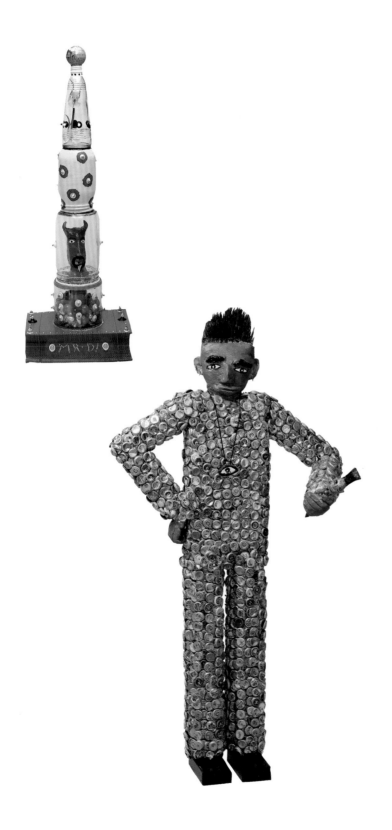

Essays by Tom Patterson

Terra Museum of American Art, Chicago

This publication accompanies the exhibition <u>Reclamation</u> <u>and Transformation: Three Self-Taught Chicago Artists,</u> curated by Tom Patterson and presented by D. Scott Atkinson at the Terra Museum of American Art, Chicago, 5 April through 31 July 1994. The exhibition was organized by the Terra Museum of American Art with the generous support of the Terra Foundation for the Arts.

Cover (left to right):

Kevin Orth, *Love from King Orthy's Cathedral of the Dreams,* 1993, cat. no. 261

David Philpot, *Damballah/Trinity,* 1991, cat. no. 48

Mr. Imagination, *Self-Portrait Cane,* 1993, cat. no. 190

Frontispiece (left to right):

David Philpot, *United Nations,* 1991, cat. no. 55

Kevin Orth, *Mr. D,* 1992, cat. no. 241

Mr. Imagination, *Male Bottle-Cap Figure with Paintbrush and Necklace,* 1992, cat. no. 154

Copyright © 1994

Terra Foundation for the Arts
3009 Central Street
Evanston, Illinois 60201

Library of Congress Catalogue Card Number 94-60034

ISBN 0-932171-07-9

Photography by Kathleen Culbert-Aguilar with the following exceptions: David Bowman (p. 34), Kevin Orth (p. 38 and back cover, center), and Tom Patterson (pps. 14, 92, 93, and back cover, top and bottom)

Edited by Sue Taylor

Designed by Three Communication Design, Chicago

Typeset in Serifa and Univers

Printed by Meridian Printing, East Greenwich, Rhode Island

Table of Contents

Preface

It is a pleasure to introduce this exhibition devoted to the work of three remarkable Chicago artists. David Philpot, Mr. Imagination, and Kevin Orth are known in the world of galleries, collectors, and critics as self-taught artists of fascinating originality and invention. To many in the community, however, the art of the museum world is dissociated from their daily lives. As a result, young people do not easily identify with artists or their art. In *Reclamation and Transformation,* the art of the museum and the art of the community become a continuum, and the artists themselves exemplify this continuum through their work, their teaching, and their efforts in behalf of children in underserved areas of the city.

These artists are actively involved with Chicago Youth Centers (CYC), a non-profit organization established in 1956 to work with youth in economically disadvantaged neighborhoods in metropolitan Chicago. A project currently underway at one of the centers, involving all three artists in the creation of a sculpture park, playlot, and community garden, has spawned a unique partnership among four area organizations—social, environmental, educational, and cultural; that project has also led to this exhibition at the Terra Museum of American Art.

The lots adjoining the Elliott Donnelley Youth Center at 3947 South Michigan have stood vacant for more than twenty years. In 1979, artist Calvin Jones painted the center's south wall with a mural dedicated to the people of the neighborhood and their African-American heritage. The mural was restored in 1993 to its original prominence, as the symbolic first phase of reclamation. Meanwhile, the Mid-South Planning and Development Commission had been working on a comprehensive revitalization strategy for the surrounding Grand Boulevard area. Collaborating on these plans was Openlands Project, a not-for-profit organization dedicated to increasing the amount and enhancing the quality of open space in northeastern Illinois. Since 1963, Openlands has protected parkland and nature preserves, and sponsored community greening efforts such as landscaping around the Robert Taylor Homes and on schoolgrounds in the Austin and Grand Boulevard neighborhoods.

With the support of Openlands, the Donnelley Youth Center is reclaiming the barren lot near the el tracks for a new playground and sitting garden. The park will be enlivened by sculpture designed by Orth, Philpot, and Mr. Imagination. Philpot, for example, will carve a gateway from tree trunks, while Orth plans a freestanding piece of found objects and sculpted concrete. As a kind of cornerstone to the park, Mr. Imagination will create a grotto (inspired by various religious grottoes in the Midwest) with the help of youngsters at the center. Already the center has been dramatically transformed with newly planted trees, shrubs, and flowers. Last year, Orth worked with children at the center to build large planters from objects found on the site.

Both Openlands and CYC envision the park as a model of community open space that reflects local values and needs, and seek to broaden the base of support for similar endeavors in the future. Terra Museum of American Art has joined their partnership, mounting this exhibition to celebrate three visual artists who also serve vital social needs in their community. Another member of this alliance of concerned organizations is the Marwen Foundation, founded in 1987 to provide quality art education, career development, and college planning to Chicago's underserved youth. Through Marwen, in the appropriate setting of the Donnelley Youth Center, Philpot, Orth, and Mr. Imagination will train selected teens to conduct art workshops for children in their own neighborhoods.

The benefits of this multifaceted partnership are both immediate and long-term, far-reaching and overwhelmingly positive for all our various overlapping constituencies. It is with great pride that we announce the partnership and encourage additional sponsorship for future collaborative programs, on the occasion of this exhibition honoring three artists who have been an inspiration to us all.

Gerald W. Adelmann
Executive Director, Openlands Project

Robert G. Donnelley
Director, Terra Museum of American Art

Introduction and Acknowledgments

It should be noted from the outset that *Reclamation and Transformation: Three Self-Taught Chicago Artists* signals a departure from past exhibitions organized by the Terra Museum of American Art. At the heart of this project is a group of extraordinary, indeed, exuberant objects made of materials salvaged from the urban environment by three artists who find value in what most of us consider refuse. In the hands of David Philpot, Mr. Imagination, and Kevin Orth, these materials are transformed into intricate carved staffs and elaborately embellished sculptures, imaginative objects which challenge both our traditional definitions of art and what we expect to see in a museum's galleries. This is especially true in the case of a museum as strongly identified with nineteenth-century American painting as the Terra Museum.

Given the unconventional nature of their work, it comes as no surprise that Philpot, Mr. Imagination, and Orth are viewed as artists outside the mainstream. They are called "self-taught" because they have arrived at their artistic identity without the benefit of formal training. Instead, they have charted their own courses and established themselves on their own terms by responding to an inner force compelling them to make art. The results are bold and direct, resonating with the personality of the respective artist. *Reclamation and Transformation* is thus not only a presentation of self-taught art but a tribute to each artist's self-determination and autonomous vision.

The title of the exhibition reinforces this point. It describes the actual creative process, the reclamation of cast-off materials and their transformation into art. At the same time, it signifies changes in the artists' lives, the reclamation of their own identities and their personal transformation into successful working artists. Their common bond is the city, which serves as the perfect backdrop and catalyst to their production. Chicago's streets and neighborhoods provide the multitude of overlooked or discarded materials required to make their art. The origin and nature of these materials leave an indelible mark on this work, which assumes the texture and vitality of the city itself.

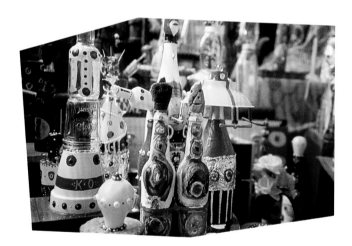

Top to bottom: Studios of Mr. Imagination, David Philpot, and Kevin Orth (photos: Tom Patterson)

However, this exhibition does not readily reveal what the artists give their city in return. Each shares his talents generously with the community by regularly conducting workshops in Chicago schools, youth centers, and hospital wards. *Reclamation and Transformation* is an outgrowth of such civic-minded activities. The collaborative project that ultimately led to their exhibition at the Terra Museum originally capitalized on these artists' creative abilities in order to reclaim and transform, not simply discarded materials, but abandoned real estate. The focus of the enterprise was a vacant lot adjacent to the Elliott Donnelley Youth Center on South Michigan Avenue near 39th Street. Two community-based organizations, the Chicago Youth Centers and Openlands Project, joined in a partnership to develop this lot into a neighborhood park. So that the new park would be a unique public amenity, the partnership enlisted the special talents of Philpot, Mr. Imagination, and Orth to create monuments after their own designs, with the participation of the children from the youth center.

Once plans for a three-person exhibition and catalogue were initiated, it was determined that the Terra Museum project would simultaneously achieve a number of different objectives, not the least of which is a celebration of the artists' work and an introduction for the museum's constituency to self-taught art. Moreover, as an event the exhibition would draw attention to the partnership's activities on South Michigan Avenue and provide encouragement for future endeavors of this kind. To realize this end, *Reclamation and Transformation* had to do more than quietly occupy the museum's galleries. From the beginning, the museum's education department set about developing numerous programs for diverse audiences and interest groups throughout the metropolitan area. For adults, there are lectures, gallery talks, and a symposium exploring significant aesthetic, social, and political issues related to both the production and reception of self-taught art; but it is in the area of children's and family programs that special emphasis has been placed. Throughout the course of the exhibition, the artists will conduct hands-on workshops. This will provide children

with the unusual opportunity not only to meet the featured artists, but to work with them directly in creating their own art from found materials.

It is the museum's intention, moreover, that participating youngsters will receive more than a lesson in making art: through their exposure to these remarkably talented individuals, they may also draw inspiration from the artists' self-reliance, resourcefulness, and independent vision. This vision cannot fail to impress audiences encountering the art of Philpot, Mr. Imagination, and Orth. Their work seems at once familiar and strange, personable and mysterious. The enthusiasm, vitality, and element of surprise they bring to their reclamation and transformation of salvaged materials is infectious and delights young and old alike. They provide us with an alternate way of viewing, and using, the plethora of cast-off articles that crowds our environment. But more importantly, through their involvement with the partnership of the Chicago Youth Centers and Openlands Project, they have established a positive model for artists' potential contribution to the improvement of our communities. In a society in which the myth and sometimes the reality of the alienated artist is still pervasive, this is a considerable achievement.

Reclamation and Transformation would not have been possible without the enthusiastic participation of numerous individuals; however, its conceptual origin can be traced to just one. This was Gerald W. Adelmann, Executive Director of Openlands Project. Jerry first told me of the alliance of his organization and the Chicago Youth Centers with the three artists and their efforts to develop a park in fall of 1992. It was Jerry who proposed that the museum join this partnership, not only to support the goals of the two organizations, but through an exhibition to make the artists and their work available to the city. Without his advocacy for the artists, this exhibition would never have taken place. Representing the Chicago Youth Centers in the partnership is its executive director, Delbert W. Arsenault. Del and Jerry shared the vision of transforming an abandoned property into a community park and worked ceaselessly to make it a reality. Their faith in the artists, belief in the project, and determination to see it through

led also to the organization of this exhibition. My greatest appreciation to them both for providing the guiding impetus.

The fourth member of the partnership is the Marwen Foundation, an organization committed to the development and implementation of art workshops in the community. Marwen joins the museum in bringing the artists and their work closer to the children of Chicago. I wish to thank Steven Berkowitz, Chairman; Antonia Contro, Executive Director; Milisa Galazzi, Director of Education; and Joanne Minyo, Project Manager and Marwen Artist-Teacher for their part in the programing of the exhibition. At the Elliott Donnelley Youth Center, thanks must go to director Marrice Coverson and community resident Rachelle Jones for their support of the goals of the partnership.

The authority and insights that the exhibition's guest curator, Tom Patterson, brings to the burgeoning scholarship on self-taught art is considerable and a major contribution to the field. His essays are groundbreaking and now form the foundation for all future work on these artists. Several other persons were essential to the creation of this catalogue. Project editor Sue Taylor managed its production with her usual aplomb and high standards of excellence, qualities that are revealed in the finished product. Credit for the handsome design of this publication goes to Three Communication Design, who adroitly navigated the demanding production schedule. And photographer Kathleen Culbert-Aguilar's ability to capture on film both the volume and complex character of the objects reproduced here makes her an artist in her own right. My gratitude to them all.

Through his gallery, Carl Hammer has long been an established champion of self-taught art in Chicago. I am indebted to him for help in securing the loans of numerous works of art appearing in the exhibition. I also wish to thank members of his gallery staff, Kirsten Cathey, Jerry Smith, and Jonathan Stein, who provided invaluable assistance in the process.

I wish to acknowledge and thank members of the Terra Museum staff who contributed selflessly to the considerable task of organizing this exhibition.

Since the project's inception, co-directors Robert G. Donnelley and Judith Terra have provided unflagging support, and Hal Stewart, Director of Development and Membership, has been key in the museum's efforts to raise funds for the partnership. Roberta Gray Katz, Curator of Education, and her department planned the multitude of programs that are an integral part of the overall project, while Jayne C. F. Johnson, Registrar, managed the shipping and handling of the loans with great acumen. In the curatorial department, preparator Richard J. Graham's assistance in the design and installation of the exhibition were invaluable; curatorial assistant Holly Wagoner balanced the multitude of details required to mount the exhibition and produce its catalogue with competent dedication; gallery technician Herbert Metzler's skills and cheerful demeanor were great assets during the long hours spent on photography; and librarian Catherine Wilson's ability to locate materials quickly, check references, and verify citations was essential.

I wish to extend my great appreciation to the Board of Trustees of the Terra Foundation for the Arts, and especially chairman Daniel J. Terra, for their immediate and enthusiastic sponsorship which made the exhibition and its education programs all possible. Although the individual lenders to the exhibition are highlighted elsewhere in the catalogue, they must also be acknowledged here as a group, both for their appreciative responses to the work of these artists and for their generous support of the project itself. And to the artists for their courage to establish their own course in the reclamation and transformation of both objects and lives, I reserve my deepest gratitude.

D. Scott Atkinson
Curator of Collections and Exhibitions
Terra Museum of American Art

Lenders to the Exhibition

AT&T

David Berube

Browdell Collection

Dr. Margaret Burroughs

City of Chicago Public Art Collection

DuSable Museum of African-American History

Herbert Waide Hemphill, Jr.

John and Laima Hood

Peter M. Howard

Mr. Imagination

Orren Davis Jordan and Robert Parker

Mr. and Mrs. Michael F. McCartin

Mr. and Mrs. William McDowell

Kevin Orth

David Philpot

Edgar Philpot

Private Collection

Jerry Smith

Dr. Hazel B. Steward

Henry Suder Elementary School

James L. Tanner

Tom Patterson

Adhocism in the Post-Mainstream Era:

Thoughts on Recycling, Redemption, and the Reconfiguration of the Current Art World

"Everything can always be something else."

With that koanlike equation, architecture critics Charles Jencks and Nathan Silver more than twenty years ago identified a cross-cultural approach to the use of materials for practical or aesthetic purposes which they dubbed "adhocism."[1] In an age overwhelmed with "isms," the term never caught on, but the widespread impulse it described is still very much with us, more relevant than ever to current developments in the social and cultural arenas, so I've chosen to resurrect it, ad hoc, for the purpose at hand.

Explaining that adhocism "consists of combining readily available subsystems ad hoc," Jencks and Silver noted that this creative mode has long been practiced among "tribal cultures"—in the "creation of masks, clothing, weapons, and shelter from... bone, shell, wood, hair, etc."—and suggested that it is "perhaps the oldest and simplest method of creation."[2] It is essentially the same practically grounded approach that anthropologist Julius Kassovic has termed "folk recycling," a virtually universal modern tradition among the economically disadvantaged, whereby "junked and industrially produced items are somehow reworked to produce 'new' items performing altered functions."[3] In the United States, legions of urban homeless practice adhocism as a basic survival skill, adapting cardboard boxes as portable shelters, for example, or grocery carts as mobile storage units.

Meanwhile, most of us participate unthinkingly in what has often been described as a "throw-away society," literally inundating ourselves with

"disposable" products and packaging. The garbage glut is rapidly overflowing the millions of acres that have been appropriated from the planet's increasingly crowded surface to contain this relentless proliferation of rot-proof waste material. The problem has become particularly severe in urban areas, and its underlying cause was succinctly identified a few years ago by self-described "junk man" Michael Helm. "Basically what we have now in the cities," he explained, "is a system designed to manufacture garbage."[4] In recent years, we've begun to consider the disastrous consequences of perpetuating this system, and the citizens of the throw-away society are gradually being forced to learn that—to quote an environmentalist adage—"there is no 'away.'" Given that unavoidable fact, adhocist practices of material scavenging and reconfiguration embody a pragmatic and creative response to the problem.

Adhocist strategies were introduced into officially sanctioned Western art by creative pioneers such as Georges Braque, Marcel Duchamp, and Pablo Picasso (who were influenced by so-called tribal cultures of the kind cited above), and were further explored and developed by Ed and Nancy Kienholz, Louise Nevelson, Robert Rauschenberg, Jean Tinguely, and others. At the same time, and in many cases long before avant-garde artists adopted this mode of combinative invention, other imaginative innovators with scant awareness of "high" art and Modernism were making works equally striking and clever in their use of industrial and commercial cast-offs and other found materials. Many such self-taught and unaffiliated adhocists no doubt lived and died in anonymity and without leaving much trace of their handiwork. Others such as Simon Rodia, builder of

the wondrous Watts Towers in Los Angeles, and James Hampton, creator of the amazing *Throne of the Third Heaven of the Nations' Millenium General Assembly* (National Museum of American Art, Washington, D.C.), have at least been posthumously recognized for their formidable achievements. Fortunately for the rest of us, their works still exist and are now widely acknowledged as having a significant place in our culture.

Dozens of artists are bringing new vitality to this eternal art tradition. Willie Cole, Thornton Dial, Howard Finster, David Hammons, Bessie Harvey, Lonnie Holley, Donald Lipski, Ed Love, Charlie Lucas, Joni Mabe, Mark Casey Milestone, Betye Saar, Ce Scott, Mary T. Smith, Simon Sparrow, David Strickland, and Michael Tracy are among its well-known and lesser-known current practitioners. As are such diverse Chicagoans as Don Baum, Raymonde Collins, Jin Soo Kim, Elizabeth Newman, Derek Webster, and the three artists represented in this exhibition.

Kevin Orth, David Philpot, and Gregory Warmack (a.k.a. Mr. Imagination) all live in inner-city Chicago and create their work largely from materials they scavenge from the streets, alleys, and vacant lots they traverse nearly every day. Their work is about reclamation and transformation (the two active components of the adhocist approach), on the literal, material level as well as the personal and social levels. Making art in this way has provided each of them with a method of self-transformation, serving as a focus for their attention during difficult times, offering a means of communication when sympathetic listeners weren't available, helping to heal deep-seated psychic wounds, and resulting in a sense of self-esteem that they hadn't been able to find in other activities. Many artists will testify to the psychological benefits of artmaking, but these three have in turn used their talents to help reclaim and transform the troubled communities where they live, through their work in Chicago's schools and community centers and their involvement with such grass-roots efforts as the Openlands Project on the city's South Side. The three are also personal friends who share a special sense of community among

themselves (along with other artist neighbors), often exchanging ideas and responding to each other's work.

Like a number of the artists cited above, Orth, Philpot, and Mr. Imagination haven't undergone any formal art training, and can thus be described as self-taught. Chicago's visual arts community has historically been more receptive to the work of such artists than have the art establishments in other American cities, so it's fortuitous that these exponents of an unofficial art happen to live here. In a recent essay about this context of appreciation, Milwaukee Art Museum director Russell Bowman describes a long-term attraction among Chicagoans "to the subjective, emotive vein in artistic expression." Citing a fifty-year tradition of interest by academically credentialed Chicago artists in "the work of untrained artists, eccentrics, isolates, compulsives, visionaries, and psychotics," Bowman delineates "an 'outsider tradition' in Chicago."[5]

His essay is an insightful treatment of important factors in the evolution of postwar art in Chicago and the U.S., documenting the city's leading role in recognizing forms of art that weren't embraced or even much acknowledged elsewhere in this country until after 1975. But his use of the word "outsider," a categorical designation that had been pre-ascribed to the art in the exhibition for which his essay was written, is unfortunate. British writer and scholar Roger Cardinal had the best of intentions when he introduced the term "outsider art" in his landmark book of the same title (1972), and it was in some ways a more satisfactory characterization than the oft-used "folk art."[6] But as critic Jenifer Borum recently observed, "Now more than ever before, the labels 'outsider' and 'folk' reveal more about those who use them than they do about the artwork and artists they are intended to identify."[7]

The term "outsider," in particular, springs from a deeply ingrained cultural chauvinism that would isolate "refined" art by those schooled in the academies from the artistic contributions of anyone else — especially anyone who is poor, non-white, elderly, or diagnosed as mentally ill. One artist represented in this exhibition has offered a bitter critique of the label from the perspective of one who has been

saddled with it: "I resent it," Philpot told a journalist recently. "Just because I didn't go to school doesn't mean I'm not qualified to do this..., but also I understand it, like racism or hatred. I've been labeled all my life—fat, black, ugly, and stupid—by the insiders. Now I'm an artist. But now I'm an outsider. What could you have done for me on the inside that would have made me more creative?" [8]

Proponents of the "outsider" label generally insist that it is meant not in a pejorative sense but simply as a convenient way to distinguish this work from the "mainstream" of modern and contemporary art. That distinction, though, has been rendered meaningless by certain cultural developments over the past twenty-five years. "Mainstream" is a presumptuous code word for a traditional European model of artistic and cultural "progress" which never had much relevance for people of non-European origin in this country; in recent years, moreover, the concept has also lost meaning for many members of the shrinking white majority. Even the institutional art world, hardly at the forefront of cultural change in our society, is beginning to reflect the reality of a "mainstream" inundated by diverse forms of art springing from a variety of sources. This exhibition is one of an increasing number of museum shows across the United States that have given testimony to that reality by highlighting the art of groups or individuals previously considered to be "outside the mainstream."

While most recent museum exhibitions of self-taught art have surveyed work by numerous artists, often from a broadly defined region, *Reclamation and Transformation* focuses on three artists from the same city who share a resourceful, "adhocist" approach to artmaking and a strong sense of engagement with their own communities. And instead of sampling only a few pieces by each artist, as is practically necessitated in survey shows, this exhibition presents unusually extensive selections from all three, creating a sense of their prolific production and of an overall context. In the following essays, I have attempted to match this aesthetic contextualization with detailed histories of the artists and critical commentary on their work's evolution, while in each case relying heavily on the artist's own authoritative words.

Never mind who taught them and who didn't, David Philpot, Kevin Orth, and Mr. Imagination are *contemporary* artists, post-mainstream, always alert to the useful but neglected, and always open to fresh alternatives. In that spirit, perhaps this exhibition will encourage those who see it to be similarly alert and to examine fresh alternatives of their own.

Notes

1. Charles Jencks and Nathan Silver, *ADHOCISM: The Case for Improvisation* (Garden City, N.J.: Anchor Books, 1973), 23, 9.

2. Ibid., 16.

3. Julius Stephen Kassovic, "Junk and Its Transformations," *A Report from the Center for Folk Art and Contemporary Crafts* 3:1 (1974?): 1.

4. Michael Helm interviewed by Beth Bosk, "Salvage as Salvation: Tales from a Junk Man," reprinted in *Utne Reader* 34 (July/August 1989): 80.

5. Russell Bowman, "Looking to the Outside: Art in Chicago, 1945-75," in Maurice Tuchman et al., *Parallel Visions: Modern Artists and Outsider Art* (Los Angeles: Los Angeles County Museum of Art, and Princeton, N.J.: Princeton University Press, 1992), 150, 172. This catalogue accompanied an exhibition that explored the influence of "outsider" art on the work of academically trained artists throughout the twentieth century.

6. Roger Cardinal, *Outsider Art* (London: Studio Vista, 1972).

7. Jenifer Borum, "Term Warfare: Can the familiar appellation 'self-taught' offer new possibilities for detente in the raging battle over terminology in the field?" *Raw Vision* 8 (Winter 1993/94): 25.

8. David Philpot quoted in Mark Jannot, "Outside In," *Chicago,* July 1992, 100.

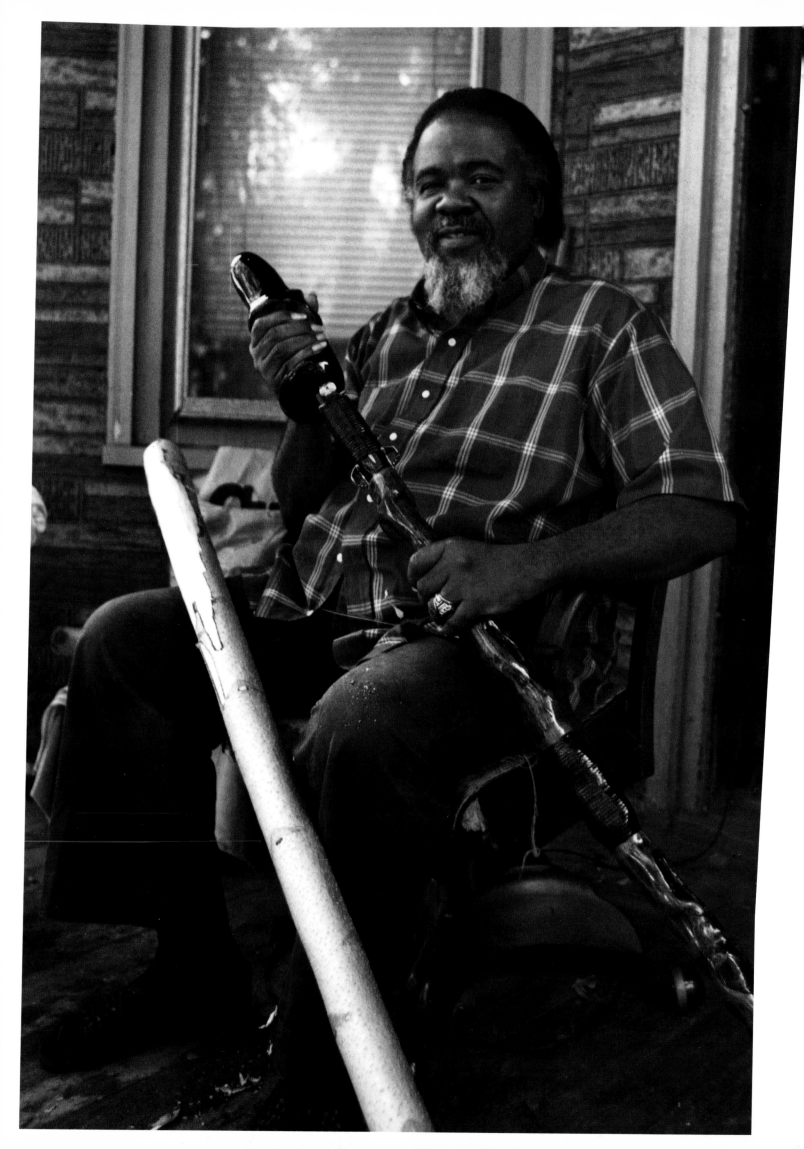

David Philpot:
Redeeming the
Tree of Paradise

"The ailanthus altissima is a tree that few people love," says David Philpot of the wood from which he carves his intricate, richly ornamented staffs. **"It grows plentifully,"** he adds, **"and people try to eradicate it from coast to coast, but...it refuses to be wiped out."**[1] Philpot is standing in his house on the South Side of Chicago, in a kitchen which doubles as an informal display area for forty or fifty tall, slender, expressive sculptural works propped against the walls, window sills, refrigerator, and stove. The artist interrupts his discourse on the ailanthus to duck into an adjoining room, where he rummages through a stack of papers until he finds the source he's looking for—an article catchily titled "Arboreal Riffraff or Ultimate Tree?" Its author, one Edmund Newton, describes ailanthus as "urban America's most persistent trespasser, spreading like gangbusters along city highways, happily breathing traffic emissions. It jams into vacant lots and untended yards, edging stealthily into driveways and flower beds.... Fiscally strapped municipalities can't work fast enough to root all the seedlings out of cracks in the pavement.... You can slash and gouge, but ailanthus keeps coming back...."[2]

A cousin of the cashew and mango, ailanthus is also known as stinkweed, trash-tree, Chinese sumac, Tree of Heaven, and Tree of Paradise. It was imported to North America from China in 1784, only a few years after the American Revolution, and in some ways it's a fitting emblem for this nation. Sturdy and tenacious, simultaneously beautiful and foul smelling, it continues to thrive amidst adverse circumstances more than two hundred years later. During the early nineteenth century, ailanthus

seedlings were planted in Chicago and other U.S. cities where less resilient trees weren't inclined to thrive, and their descendants can today be found by the multi-millions in all of these cities as well as throughout much of rural America. A mature female Tree of Heaven drops several hundred thousand seeds in a season. Those that take root grow rapidly, up to twelve feet high in a year, and spread laterally by way of prolific sucker-equipped root systems.

Philpot didn't know any of this twenty years ago, didn't even know the name of these trees when he began selectively cutting them down and transforming them according to his own then-emergent artistic vision. He just liked them as raw forms, admired the smooth grace and simplicity of their gently tapered trunks. And the wood was easy to carve. Chopped off at the base and stripped of its limbs, an ailanthus tree is already a natural staff. Subjected to Philpot's sculptural manipulations and embellishings, it becomes a potent symbol of artistic and spiritual authority, an embodiment of miraculous transfiguration.

Philpot also didn't know that he had it in himself to create such things. Plagued by culturally conditioned self-doubt, he resisted for many years the impulse he had felt since childhood to carve a walking cane. But during his youth he quietly collected bits of wood and often carried an unembellished stick around with him, as if awaiting a burst of inspiration he somehow knew would one day strike. His art, and his account of the process by which he arrived at making it, is a bold study in intuitive self-empowerment.

Born at Chicago's Providence Hospital on 21 November 1940, Philpot has lived on the South Side his entire life, with the exception of three years he spent in the army during the early 1960s. **"My mother was a Poindexter, and she came to Chicago from Ohio in the 1930s,"** he recounts. **"My father's family was from Augusta, Georgia, but I don't know much about him. I only saw him once, in 1952, about three or fours years before he died. But there were no artists in my family that I know of."** Growing up fatherless in an economically disadvantaged African-American family during World War II and its aftermath was difficult enough, in Chicago or anywhere else in the United States. But for the young Philpot the impact of this harsh reality was compounded by other not necessarily unrelated problems. **"I had a childhood stammer and couldn't talk very good,"** he recalls. **"And a stammering person doesn't do well in school. I was always told I was fat, slow, dumb. And if you keep hearing those kinds of things about yourself, it's easy to start believing them. I was never very athletic, and I didn't finish high school until I was twenty-one."**

The artist remembers **"at a very early age noticing the canes that a lot of older people older people walked with. I've always loved the feeling of wood in my hands,"** he says, **"and as far back as I can remember, I wanted to make a cane. I did some wood-shop projects at Chicago Vocational School, where I went to high school from 1957 to 1959, and I began to experiment with carving when I graduated from Dunbar High in 1961. About that time, I bought a plain cane with a doorknob handle on it, and I carried it with me overseas when I went into the army in 1962, but I didn't do any carving on it."** Philpot's military service coincided with the early stages of the Vietnam War, but he was fortunate enough to be assigned elsewhere. He spent most of his tour of duty as a teletype operator in Berlin. **"I loved it over there,"** he says. **"In Berlin, it was almost better to be black than white. I got along great with the German people, and**

it was just wonderful being able to go anywhere and do anything without any consciousness of your color. The whole experience was like something out of a story book." But his return to Chicago was an abrupt return to reality.

The late 1960s was a charged and turbulent era at all levels of U.S. society, but particularly so in urban African-American communities like Chicago's South Side. Philpot arrived back in the 'hood in July 1965, a few months after Malcolm X's assassination in Harlem and only weeks before the infamous riots in the Watts district of Los Angeles. These events established the mood of tension, frustration, and rage that permeated black neighborhoods in most American cities through the end of that fiery decade. Enthusiasm for non-violent strategies had begun to wane as it became increasingly apparent that the civil rights movement was making little tangible difference in the conditions under which most black citizens lived. Eldridge Cleaver cautioned at the time, "Violence becomes a homing pigeon floating through the ghettos seeking a black brain in which to roost for a season." [3] Cleaver and others like Stokely Carmichael, H. Rap Brown, Angela Davis, and Huey Newton represented a young generation of militant African-American activists who were forcefully espousing revolutionary philosophies of black power, black consciousness, black nationalism, and Pan-Africanism. On the black cultural front in Chicago, those philosophies found expression in the music of Anthony Braxton, Muhal Richard Abrams, and the Chicago Art Ensemble, and in visual art most prominently through the paintings of Jeff Donaldson, Wadsworth Jarrell, and other members of the AFRI-COBRA group, founded in 1968—the same year Dr. Martin Luther King, Jr., was murdered.

Philpot says he remained relatively unaffected by these dramatic developments. **"I was totally blind to any kind of art at that time,"** he somewhat sheepishly recalls, **"and I didn't get involved in politics. I read and I heard and I saw, but I wasn't much affected. I was too busy working hard, trying to make it, trying to survive."** In this respect, he was no doubt like many black urbanites during the sixties. He spent his first few months back in Chicago struggling to

Ailanthus growth, Chicago, 1993 (photo: Tom Patterson)

reunite his family, for in his absence, his six younger sisters had been placed in foster homes, and his mother was living alone on welfare. With considerable effort, Philpot was able to bring them all back together under one roof. Soon after his return, he found a job selling lingerie in a department store, and it was there that he met Jean Rouse, whom he married in 1966 after a relatively brief courtship. Their first child was born that same year, and in 1967 Philpot went to work as a part-time driver for the Yellow Cab Company, where he was to remain employed for the next seventeen years.

Despite his disengagement from the socio-political battles that raged around him, the sixties ended dramatically for Philpot and his small family. In December 1969—just a few days after police killed Fred Hampton, the twenty-one-year-old leader of the Illinois Black Panthers, in his west-side Chicago apartment—Philpot's own apartment at 63rd Street and Blackstone was destroyed in a fire, which he still suspects was set deliberately. The dawn of the 1970s thus found the young Philpot family moving into "the projects," specifically the Robert Taylor Homes at 54th and State Streets. At the time, Philpot was working full time as a janitor for the cab company, and as he says, **"I was getting frustrated with my life."**

It was about this time, shortly before the birth of his second son, that he found himself again quietly ruminating on his long-suppressed dream of carving a cane. He remembers **"walking down Wells Street one day in 1971, when I saw these fancy canes in the window of a tobacco shop. But they were so marvelous that it just destroyed me, because I couldn't foresee myself ever being able to make anything that great."** However, as he stood in front of the shop display admiring the craftsmanship of these canes, he had a flash of inspiration. **"About a week earlier I had seen the movie The Ten Commandments with Charlton Heston as Moses,"** he explains. **"And while I was looking at those canes I thought about the staff that Moses carried in that movie and used to do all these miracles, like the parting of the Red Sea. And I said to myself, 'I'll be different. I'll make a staff.'**

"A couple of weeks later," he continues the story, **"I was visiting a friend in another part of the projects, about four blocks from where we lived. And as I left his place and walked outside, I heard someone say 'David!'**—he stage-whispers his own name—**"'Over here!' And I looked, and I saw no one, so I started to go on. Then I heard it again: 'David! Over here!' Well, as I turned to focus on where this voice was coming from, I saw a group of trees growing up around this entrance to the projects. And I walked up to it and began to look at the growth that was in it, and right there in the center was this beautifully shaped tree trunk."**

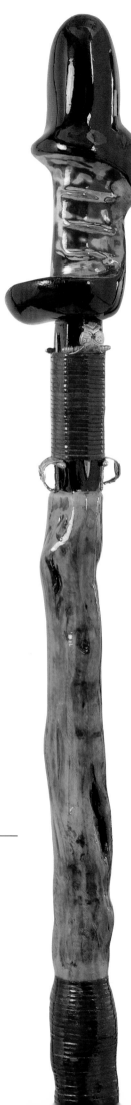

Genesis,
1971, cat. no. 2

He stands in front of the refrigerator, staring thoughtfully at the staff he has just removed from a cluster of slightly taller staffs leaning against the wall. After a pause, he picks up the narrative: **"For a period of about two weeks after that, when I got up in the mornings I could feel this growing sense of urgency, almost like I was getting hungry. And it finally occurred to me that the urge I was feeling was to go back over to where those trees were and cut down this particular one that had spoken to me. So, late one Saturday night, about two or three a.m., I went back with a saw and started cutting it down. But all of a sudden I heard someone say, 'Hey, what are you doin'?! Stop it!' And I saw these two security guards coming toward me. And the closer they got, the faster I sawed, and I got the tree down before they got there. Then I jumped over the fence and ran, with the saw in one hand and the tree in the other. And man, these guys kept chasing me and calling me names and threatening my life. And I kept on running until finally, lo and behold, the noise behind me ceased. So I made it home with that tree, and I used it to carve this staff."**

The artist's right hand encircles the distinctive black-painted grip that he formed with wood putty at the top of this important initial piece. He holds it out at eye level so that its smoothly polished phallic crown catches the sunlight, and he says, **"It took me a whole year to carve this staff. That was before I understood that my staffs talk to me, so I didn't really know what I was doing or why I was doing it. I wrapped this leather string around it here near the bottom and up here near the top, and then I squared off this whole section here where the grip is now. That just destroyed the whole effect that you got from looking at this beautiful piece of wood, but I let it stay like that for a while, and I carried it around with me for about three months. Then one day I saw a policeman with his gun in his holster, and I noticed this gun had a very large hand-grip, so I decided to put a grip**

like that on this staff. At first I carved these slits along the top for my fingers, but then I filled them in with wood putty, and I put too much on there. That gave me the idea to build the top up with the putty, and I kept working with it until I got it looking like it does now. **That was me learning to listen** to what the staff wanted done to it. But when I finally got it like this, it was everything I had wanted to do— to create something beautiful and magnificent. I call it <u>Genesis,</u> since it was my first. And the feeling I got from making it was so good, it was just like winning a lottery. So I went out and got a couple of trees and began to carve them. And I've been carving ever since. After making this first staff, whenever I would get bored or upset, I'd create my staffs."

This creative activity and its immediate results were their own reward, as far as Philpot was concerned. He immediately took to carrying a staff with him wherever he went, so his neighbors, friends, and family made up the "audience" for his work. But it didn't occur to him that he was making art or that it might be of interest to anyone he didn't know personally. As he puts it, **"For the first ten years that I was making my staffs, I was not an artist. I didn't try to sell any of my staffs or show them to anybody. Then sometime in 1981, this woman I know told me what I was doing was sinful and God didn't like it. She reminded me about the story in the Bible where the man buries his talents and loses them, and she said I was wrong for not sharing my talent."**

Philpot found this accusation troubling and confusing. He had never had a high opinion of himself, and despite his personal enthusiasm for carving and embellishing these ailanthus scepters, his profound self-doubt so distorted his view of his own work that he assumed no one else could possibly be interested. Having been challenged on this assumption, he felt compelled to test it. Soon after the conversation with his friend, he learned that Chicago's DuSable Museum of African-American History was about to

present its annual Arts and Crafts Festival, and he decided to use this as the occasion for putting his work before the public. When he showed up at this event on a July weekend in 1981 with more than a dozen of his staffs, his intent was, in his words, to **"show everybody that what I was doing was nothing. I was thinking everyone would just pass by and wouldn't take any interest in my staffs. But as the day wore on, people kept gathering around me and asking me questions: 'What are they?' 'How long does it take to make one?' 'How much are they?' I didn't think anyone would be interested in buying them, so I hadn't even thought about how much to charge for them. Then at the end of the day they gave out awards, and I won first prize—two hundred and fifty dollars and a little statue."**

The attention and the award, Philpot says, **"took me aback,"** and provided the incentive for him to enter his work in other art fairs, where he won more awards. **"But that still didn't give me any real confidence,"** he admits. **"The staffs may have been beautiful and magnificent, but the person who was doing the work and making these things had no self-esteem. He was nothing."** About two years after the 1981 festival, the curatorial staff at the DuSable Museum invited Philpot to show some of his staffs in what would be his first formal exhibition, *Four Afro-American Folk Artists.* Also to feature work by Derek Webster, William Dawson, and Giles Liddell, this six-month exhibition was scheduled for an opening at the museum in late April 1984. Philpot accepted the invitation, and the resultant show might have boosted his self-image had its impact not been over-ridden by an unfortunate turn of events that occured in the meantime.

On 4 January 1984, as if to confirm his low opinion of himself, Philpot was fired him from the mechanic's position at Yellow Cab to which he had been promoted only two years earlier. While collecting unemployment compensation and pursuing a futile job search, he used some of his newfound spare time to get

involved in community politics, volunteering as a "block captain" to help get out the vote for then alderman Marlene Carter in her successful bid for re-election. After the election, he enrolled in Illinois Technical College and spent a year and a half earning a degree in consumer technology, certifying his expertise in repairing home electronic equipment. But he was still unable to find employment. Finally, in the summer of 1986, he was offered a job as a conductor for the Chicago Transit Authority, a position he says was a belated reward for his work in Alderman Carter's behalf two years earlier. He eagerly accepted and was asked to report for work on 15 September, but his plans were dramatically derailed just five days earlier, when he suffered a heart attack. He underwent angioplastic surgery, and it took him a year and a half to recover his health. During that intensely difficult period, his debts mounted, the utilities at his house were disconnected, and his family barely had enough to eat.

From his very different vantage point six years later as a successful and widely respected artist, Philpot looks back on this period of extended personal disaster as a painful but necessary chapter in the fulfillment of what he considers his divinely guided artistic destiny: **"This whole chain of events—losing my job and my health, being poor and cold and hungry and depressed— led me to finally realize that this was God's way of waking me up to what I was supposed to be doing. I had asked him for the ability to carve staffs, and he had given it to me. And during all those months after my heart attack, this was my salvation. Instead of taking drugs and whiskey, I worked on my staffs, and this helped me to escape my problems. This is what saved me from going crazy and committing suicide—this and my family and my sister Cynthia, who has stood by me all these years. And I came to realize that this was my blessing, and that making these staffs was my spiritual way of communicating with the people and letting them know how I feel and what my life is about."**

Many admirers of Philpot's staffs have been quick to note their apparent affinities with the ceremonial staffs carried by certain community leaders and mythological figures in various African traditions. Among the Yoruba, for example, special staffs that "collectively symbolize the ancestors and cryptically communicate awesome levels of initiation" are associated with the deities Obaluaiye (an earth god who can heal or inflict disease) and his mother, Nana Bukuu (who represents "the courage and accomplishment of women"). And in Ghana, the chiefs of traditional communities are assisted by individuals known as "linguists," who carry staffs carved with imagery and abstract motifs representing "the beliefs and aspirations of the entire state or clan." It has also been noted that the mirrored inlays Philpot has created on several of his staffs are "in many ways like the protective mirror placed in the stomach area of a Kongo ancestral figure."[4]

In the early 1980s, when he first heard people remarking on the African influences they saw in his work, Philpot says he was offended. **"I didn't know anything about African art,"** he explains, **"so I didn't understand how they could make that association with my staffs. They were complimenting me, but I didn't have enough sense to know it, because I had never really seen or read anything about African art."** It wasn't until 1988 that he first encountered an example of a traditional African staff (in a photograph at the Art Institute of Chicago), but by then he had already been moved to reconsider his attitude about the African association. In 1983, his stepsister, who worked at the time in the U.S. Social Security Administration's Chicago headquarters, had invited him to give an informal talk about his staffs to her co-workers. As part of the same program, it turned out, other employees were presenting a show of contemporary fashion based on traditional African clothing. On the spur of the moment, several of the models asked to carry his staffs, and he gladly obliged. The results impressed him greatly. **"They looked like a group of African dignitaries,"** he remembers, **"all dressed up in these African clothes and carrying my staffs.**

I felt like I was at some kind of special ceremony or African ritual. After that, I was able to accept the connection between my staffs and African art, because I began to understand that this was my heritage coming out in me without me even knowing what was happening."

While he resolved this issue for himself a decade ago, the artist's initial struggle with it reflects a tension that critic Lucy Lippard has cited as inherent to the African-American experience. "In the African-American community," she writes, "...artistic references to African cultures can be bitterly symbolic of lost freedom on one hand; on the other, they can be hopefully symbolic of the reclamation of a culture— a freedom to reconnect and remember and perhaps to be freed from the overwhelming tragedy of the past."[5]

Although he hasn't actively sought out extensive information about the use of ritual staffs, Philpot has in more recent years crossed paths with Africanists and others well versed in such traditions. On occasion, they have shared their knowledge with him, and sometimes these exchanges have informed one or more of his subsequent creations. One of his most striking works, for example, is entwined with a three-headed snake which he has carved in meticulously detailed high relief, and he has titled it *Damballah,* for the Dahomean serpent deity also honored in the Afro-Catholic Vodun tradition of Haiti. This god's image, not incidentally, appears in the form of carvings on wood canes and poles.[6] The crown of *Damballah* is studded with cowry shells, which in traditional Dahomey were emblems of spiritual regeneration.[7] Most of Philpot's staffs, though, don't bear African titles or intentionally incorporate African references. Still, his use of mirror fragments, jewellike encrustations, criss-cross patterns, diamond shapes, zig-zags, and emblems of omni-directional vision is remarkable in the way it parallels time-honored African symbolic motifs.

In asserting that his heritage emerges unconsciously and that his staffs speak to him as he works, Philpot in effect acknowledges himself as a spontaneous manifestation of the "atavistic aesthetic" espoused

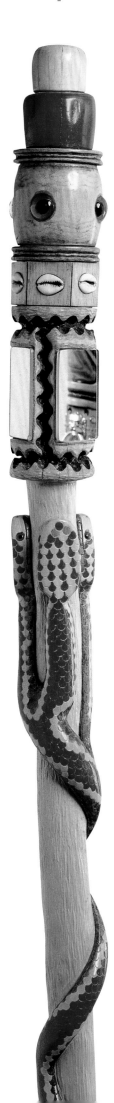

Damballah,
1990, cat. no. 38

by AFRI-COBRA artists twenty-five years ago in their effort to create a new African-American art. They suggested that all people of African descent had "an innate knowledge of art based on African cosmogony, mythology, culture, and history," knowledge that had been "ancestrally or genetically transmitted through the collective unconscious." According to their analysis, there is a blood-carried strain of "TransAfrican Art," to use Donaldson's term, which "tends to re-emerge full force as a sort of protective guardian spirit during periods of social crisis."[8]

And perhaps during periods of personal crisis as well. It was as if Philpot, while nearly destitute and slowly recovering from his heart attack in the late 1980s, managed to summon this "guardian spirit" by immersing himself in his artistic process, thus imbuing the resultant creations with special talismanic power. In that sense, his staffs are like highly elaborate, elegantly symmetrical analogues of the sacred Kongo charms known as *minkisi* (*nkisi* in the singular), in which such materials as wood, shells, beads, nails, and mirror fragments are fused together for purposes of healing, protection, and attracting good luck.[9] Their magic began to work for Philpot in tangible ways one day in 1987, when he visited Chicago's River North gallery district and walked into Carl Hammer Gallery with a half dozen of his staffs. Fully expecting rejection, he was startled by the warm reception Hammer gave him on seeing the staffs. A specialist in the work of self-taught artists sometimes known as "outsiders," Hammer was immediately drawn to Philpot's work and offered to represent him.

The dealer kept all the staffs the artist had brought with him that afternoon and showed them in February 1988 in a group exhibition titled *Outsider Art: The Black Experience.* Hammer has since helped to build a market for Philpot's work and establish prices to compensate him fairly for the many hours he devotes to making each staff. In 1989 and 1991, Philpot's work was exhibited in additional group shows at the gallery, and in a solo exhibition in 1992. Meanwhile, Philpot gained national attention when a group of his staffs were included in the tour of *Black*

Art/Ancestral Legacy: The African Impulse in African-American Art. One of this exhibition's curators, Regenia Perry, had seen Philpot's work in 1984 at the DuSable Museum and subsequently arranged to borrow six staffs from him for the duration of the tour. These were among more than 150 works by forty-nine artists represented in the exhibition, which opened at the Dallas Museum of Art in December 1989 and later traveled to museums in Atlanta, Milwaukee, and Richmond.

Four years after attending the Dallas opening and more than twenty years after making his first staff, Philpot says it was the sight of his work in *Black Art/Ancestral Legacy* that finally provided him with a measure of the self-confidence he had up to that point always lacked. **"All that time,"** he recalls, **"I had refused to let anybody convince me that I had any talent."** He shakes his head and smiles softly at his own stubbornness. **"I had fought everybody who came my way trying to tell me that I was an artist or that there was any real value to what I was doing."** Having stopped battling with his admirers, he nevertheless remains an exceptionally modest, sometimes self-effacing man with a conspicuous inclination for down-playing his achievements. But what he has accomplished speaks eloquently for itself. His growing body of work includes well over two hundred aesthetically formidable, labor-intensive pieces; many of these have been exhibited in museums and galleries and are now housed in public or private collections. Despite his lack of academic credentials beyond a high-school degree, he has in recent years served as a visiting artist and instructor in college and university art programs, and he currently spends much of his time teaching and demonstrating his techniques in community centers and public schools around his hometown.

Just as he converts the humble and widely despised ailanthus trees clogging the bombed-out blocks of south-side Chicago into objects of radiant flash and intricate beauty, so has he managed radically to transform the circumstances of his life through his own sensibilities, abilities, and quiet dedication. Although he hardly planned or dreamed it would be

this way, his artmaking activities have enabled him to reclaim his cultural heritage, find a new sense of accomplishment and self-worth, and establish a place for himself as a respected artist, teacher, and role model within his own community and the culture at large—that great wide world beyond the South Side, in which he never imagined anyone would know or care who David Philpot is.

Notes

1. All otherwise unattributed quotations are excerpted from interviews with the artist conducted by the author on 15 July and 14, 15, 22, 24, 27, and 29 November 1993.

2. Edmund Newton, "Arboreal Riffraff or Ultimate Tree?" *Audubon Magazine* 88 (July 1986): 12.

3. Eldridge Cleaver, *Soul on Ice* (New York: McGraw-Hill Book Co., 1968), excerpted in Gerald Howard, ed., *The Sixties* (New York: Washington Square Press, 1982), 129.

4. Robert Farris Thompson, *Flash of the Spirit: African and Afro-American Art and Philosophy* (New York: Random House, 1983), 69, 68; E. Ablade Glover, "Linguist Staff Symbolism," printed handout accompanying a workshop by David Philpot at Hinsdale South High School, Darien, Ill., May 1992; Robert V. Roselle, Alvia Wardlaw, and Maureen A. McKenna, eds., *Black Art/Ancestral Legacy: The African Impulse in African-American Art* (Dallas: Dallas Museum of Art, 1989), 247.

5. Lucy R. Lippard, *Mixed Blessings: New Art in a Multicultural America* (New York: Pantheon Books, 1990), 58.

6. See Leslie G. Desmangles, "The Many Faces of Vodun," and Dolores M. Yonker, "Invitations to the Spirits: The Vodun Flags of Haiti," in *Haiti: Flesh of Politics/Spirit of Vodun* (Storrs, Conn.: University of Connecticut, 1991), 23, 27, 32.

7. Thompson, *Flash of the Spirit,* 27.

8. Nubia Kai, "AFRICOBRA Universal Aesthetics," in *AFRICOBRA: The First Twenty Years* (Atlanta: Nexus Contemporary Arts Center, 1990), 6, 7.

9. Thompson, *Flash of the Spirit,* 117.

Brain II,
1993, cat. no. 72

Brain I,
1993, cat. no. 71

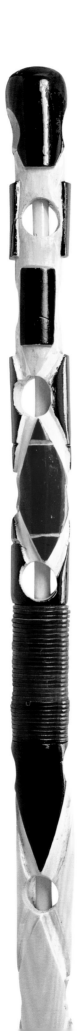

Mixed-Up,

1973-82, cat. no. 5

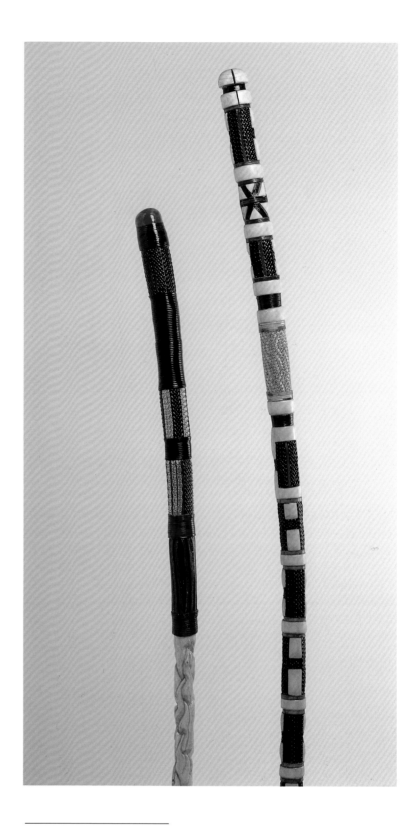

Flames,

1974-93, cat. no. 7

Edgar Philpot,

1973, cat. no. 4

Staff,
1987, cat. no. 24

Janey,
1974-87, cat. no. 6

Bubbles,
1987, cat. no. 20

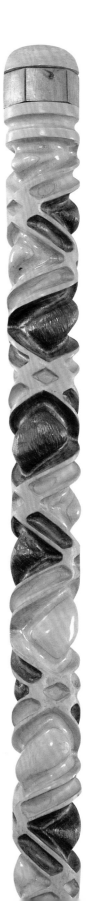

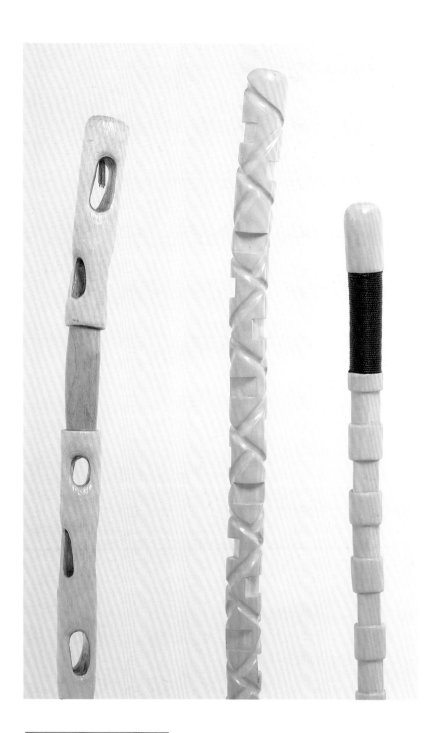

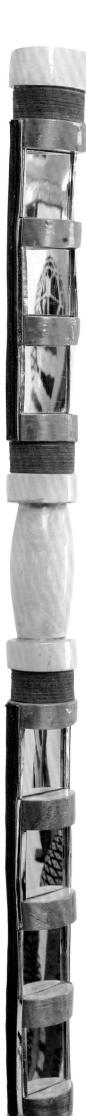

Staff,
1975-84, cat. no. 8

Mancuso,
1983, cat. no. 13

**Three Different
Shapes,**
1992, cat. no. 67

Mirrored Staff,
1982, cat. no. 12

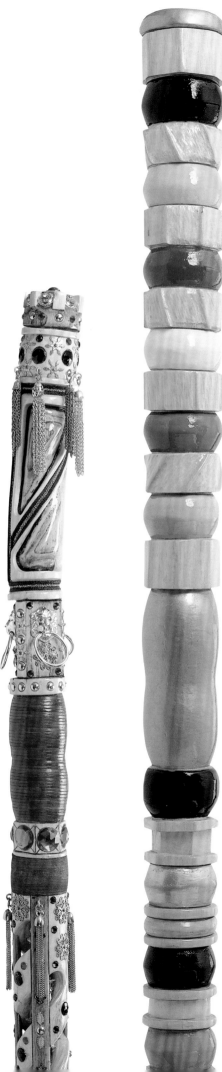

King Harold,
1988, cat. no. 26

Six Years,
1988-93, cat. no. 27

Serpent Staff,
1989, cat. no. 30

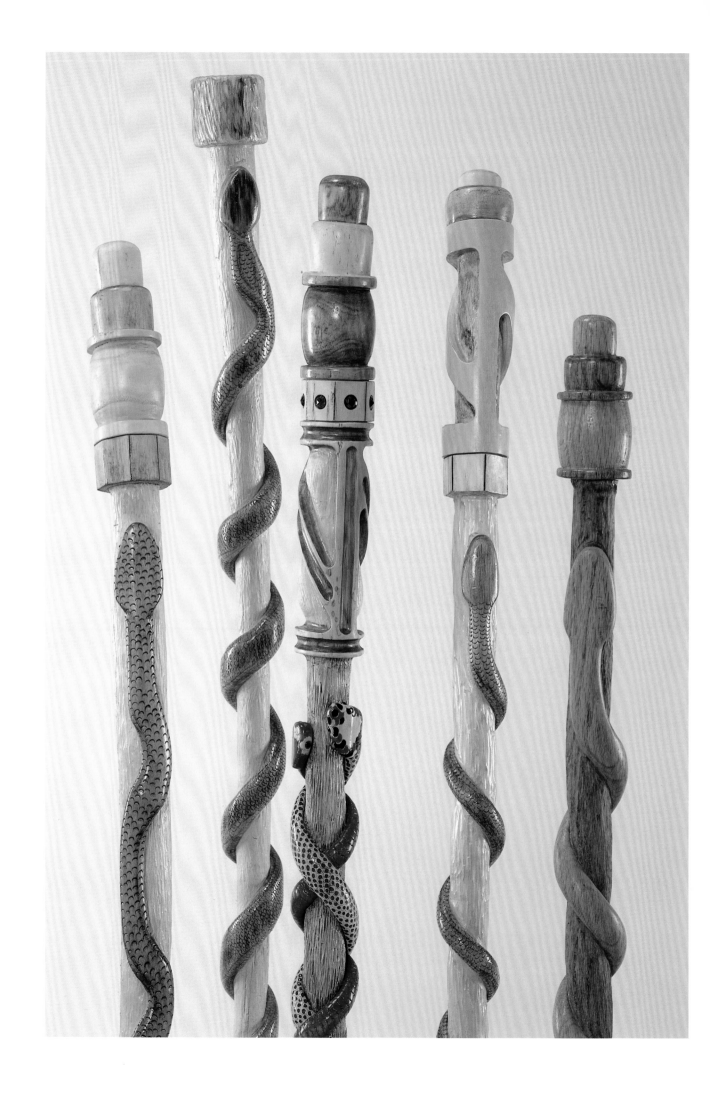

Serpent Staff,
1991, cat. no. 49

Serpent with Apple,
1989, cat. no. 32

Struggle,
1989, cat. no. 35

Serpent Staff,
1989, cat. no. 31

The Bannister Snake,
1989, cat. no. 28

**Black and Red
Serpent,**
1990, cat. no. 37

**Essence of the
Universe #4 (The
Eyes Have It),**
1990-93, cat. no. 41

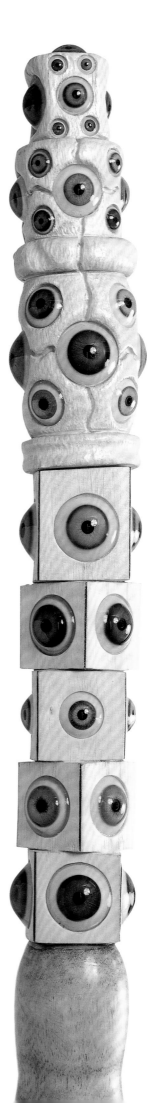

Tribute to
Malcolm X #2,
1991, cat. no. 53

Tribute to Malcolm X,
1991, cat. no. 52

Tribute to Malcolm X,
1991, cat. no. 51

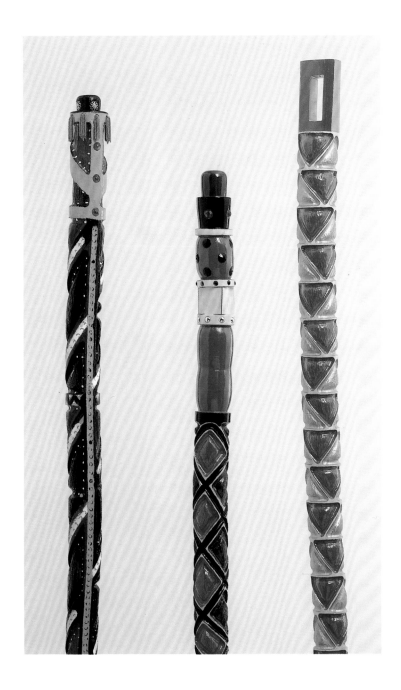

Staff,

1992, cat. no. 64

Staff,

1992, cat. no. 63

Hearts,

1992, cat. no. 61

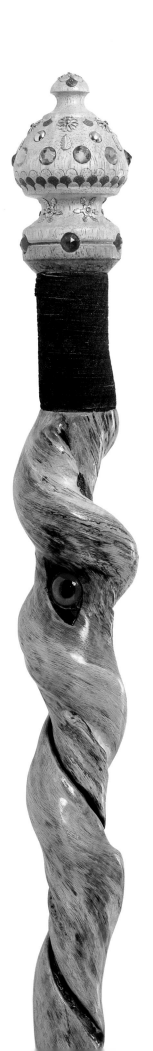

Twisted Limb,

1991, cat. no. 54

Essence of the Universe #5,
1991-92, cat. no. 56

Essence of the Universe #11,
1991-92, cat. no. 58

Essence of the Universe #2,
1989-92, cat. no. 36

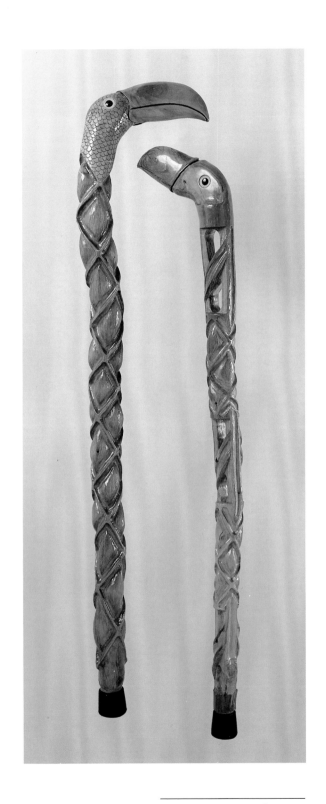

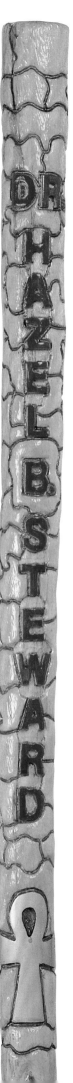

Dr. Hazel B. Steward,

1993, cat. no. 76

Tucan-Headed Cane,

1992, cat. no. 68

Puffin-Headed Cane,

1990-93, cat. no. 47

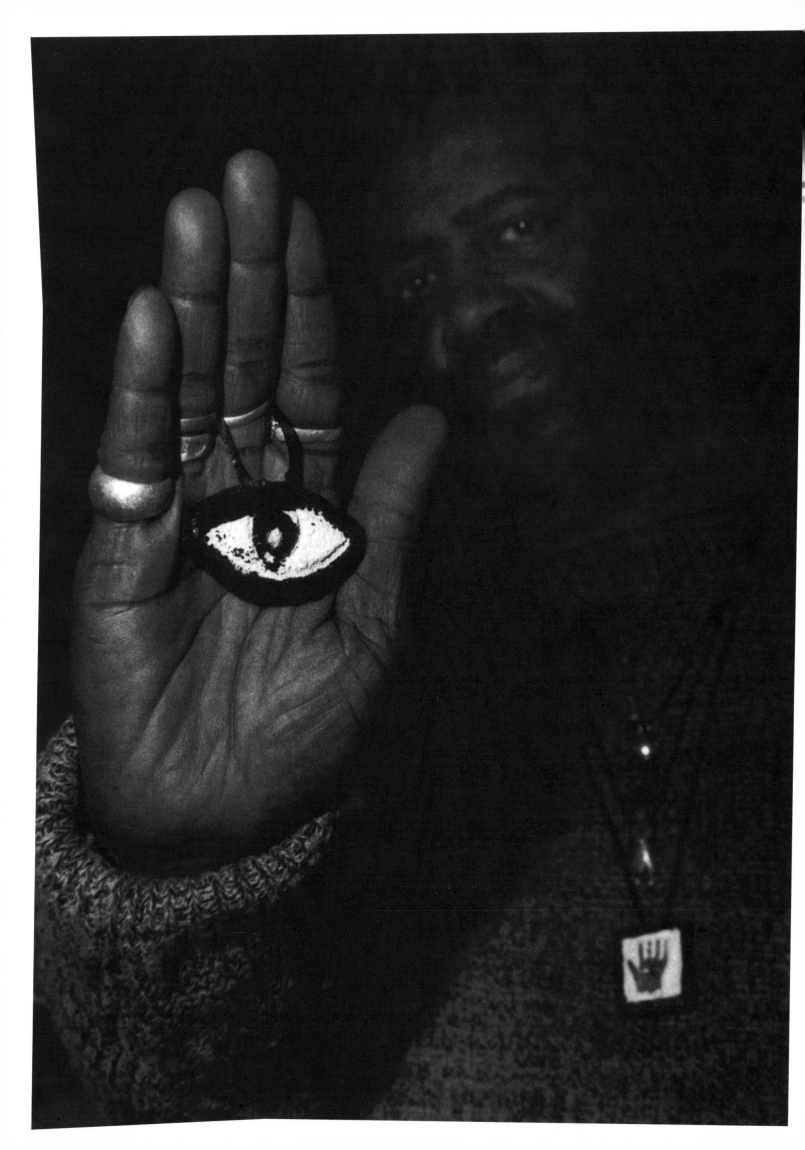

Tom Patterson

Manifesting the World of Mr. Imagination

"The disembodied single eye," Roger Cardinal has noted, "is a feature so widespread across different cultures as to make it hazardous to pin down any one universal meaning."[1] Regardless of its ancient, multicultural history, the eye is an appropriate signature emblem for Gregory Warmack, who has invested this resonant symbol with particular personal meaning. A lone eye painted on cardboard, a concise visual embodiment of his singular artistic vision, floats behind glass in the door leading to his apartment and studio on Chicago's North Side, five blocks from Wrigley Field. Gesturing at this homemade threshold amulet as he welcomes visitors into the building, Warmack explains it with his favorite pun, which doubles as a self-introduction: **"The eye stands for Mr. Imagination."[2]**

The playfully bold moniker was adopted more than a decade ago by this soft-spoken, relentlessly cheerful, prolifically creative living legend on the Chicago art scene. The artist's voluminous body of work includes several thousand industrial-sandstone carvings, hundreds of masklike figures made of discarded paintbrushes and brooms, many dozens of additive objects created from wire-strung bottle caps, scores of columnar totems built with wood putty and scrap materials, and numerous other works ranging from miniature buildings and furniture to visionary paintings and abstract found-object constellations. Since his first formal exhibition in 1983, many of these pieces have made their way into public and private collections, but his second-floor apartment at eye level with the adjacent el-train track remains constantly glutted with artwork in all these varied media.

In the spirit of his work, the artist is himself a coolly charismatic, flamboyant individual. Slim and handsome, with a neatly trimmed beard and an immaculately coifed pompadour, he looks much younger than his forty-six years, somewhat resembling Chuck Berry when he was still a 1950s rock-and-roll idol. With something of Berry's sartorial flair, Mr. Imagination favors dapper attire, accenting black dress shirts, Italian shoes, and leather jackets with lots of silver jewelry and his trademark bottle-cap neckties. It doesn't take long for a layer of mythology to accumulate around such exceptionally colorful figures as "Mr. I," as he's known to friends and neighbors. In this case, myth has it that Warmack became an artist and assumed his new identity as Mr. Imagination in the immediate wake of a violent assault he suffered nearly sixteen years ago. But as often happens, the real story behind the legend turns out to be more complicated.

In fact, Warmack has made art in one form or another for virtually his entire life, and he didn't assume his audaciously catchy alias until a year or more after the oft-cited attack, which the artist confirms happened more or less as it has been portrayed in subsequent accounts. On a warm summer evening in 1978, Warmack nearly lost his life when he was brutally mugged on a dark south-side Chicago street just a few blocks from the apartment where he lived, and this incident did indeed mark a turning point in his life. At the time he was thirty years old and unknown to the art world. An entrepreneur of the streets, he had found a relatively practical outlet for his creative abilities in the design and production of jewelry and other handicrafts from plaster, beads, carved wood, bobby pins, and cowry shells.

Unable to afford his own place of business, he made most of his sales in local restaurants and bars. On that fateful evening, he had just left a neighborhood tavern carrying some of his wares in a sack and was walking north on May Street between 63rd and 62nd Streets. As he crossed an alley, Warmack recalls, someone grabbed his arm from behind and demanded all his money. He resisted, and during the brief struggle that ensued he remembers dropping his bag of cowry-shell jewelry just before he heard **"a loud noise that sounded like a cannon going off."**

He recounts in vivid detail the events that followed: **"Suddenly my stomach started burning like someone had opened it up and filled it with hot coals. I realized I had been shot, and my whole life went by in a big flash. I was still standing up, and I pushed the guy away from me and took off running across the vacant lot that was full of tall weeds and garbage. I made it into this bar on the corner, and I ran in with blood coming out of my mouth and my stomach and said, 'Please help me, I've been shot.' By that time everything had started to get real dim and I collapsed in the bar. I don't remember what happened then, but I was later told that an old man called the police, and when the ambulance came, they found me lying in the vacant lot next door. I guess the owner of the bar got somebody to take me outside because he didn't want me to die in his place."**

Warmack had been shot twice in the solar plexus at point-blank range, and he arrived at the emergency room of St. Bernard Hospital in critical condition. Doctors there were able to repair his stomach by essentially stapling the organ back together with metal clamps. They removed one of the bullets that had wounded him, but the second was lodged so close to his spine that they feared any attempt to extract it might prove fatal. At some point during this tense procedure, Warmack fell into a coma. He recalls having the sensation that he **"went up into the air off the operating table. It seemed that I had left the room, but I could see my body still lying there on the table. Then I started seeing this bright light, and I went right into this big beam of light. It felt really wonderful and peaceful, and I just kept going through it. I don't know how far I went, but it seemed like a real long ways. And while I was traveling through this light, I could hear all these voices of people talking to me, but I couldn't talk to them.**

"That was my mother and my sisters and other people that had come to see me in the hospital, but I didn't realize who it was or where I was, because I felt like I was traveling through this bright light the whole time. And you know what? This might sound strange, but I had seen that same type of light this one other time, when I was about twelve or thirteen years old. I was living with my mother and my brothers and sisters at the time, in a house on 62nd and Green—in fact, it was just six blocks from where I got shot—and I was in the back yard by myself when I seen this ball of bright light that looked like it just came up out of the ground. It was just this glowing light, brighter than any light I had ever seen before, and it floated there for a few minutes, and then it just vanished."

The mugging was an explosive disruption in the current of Warmack's life, and its impact on him was so profound that to this day he refers to events in his past as having occurred either **"before I got shot"** or **"after I got shot."** Otherwise, his sense of time is free floating. Aside from knowing he was born on 30 March 1948, and that he was shot during the summer of 1978, he has little interest in connecting his memories to particular dates or even years. In one of his found-object pieces, made sometime after the shooting, he mounted a burned and blackened, partially melted plastic alarm clock on a small slab of wood and labeled it *Time*; the image serves as an apt symbol of his detachment from the concept of linear, chronological time. This presents some difficulties for anyone seeking to understand his past and track the evolution of his work, but extensive discussions with Mr. Imagination and interviews

with his friends and family yield enough specific information to construct a biographical sketch encompassing the most important stages in his artistic development.[3]

Warmack was the third of nine children born into a poor family on Chicago's West Side. "He was two months premature, and he didn't weigh but four pounds," recalls his mother, Margaret Warmack. "We carried him around on a little pillow when he was a baby." He doesn't remember his father, who died several years before the family moved to the South Side in the early sixties. Several traits distinguished Greg, as his family calls him, from most of the other children in the neighborhoods where he grew up. One was his artistic talent. **"I knew I was an artist when I was real, real young,"** he says. **"I don't really remember when I started drawing and making things, but it just seems like I was always doing it."** Another special characteristic was that he periodically had seizures throughout his early childhood. Although she doesn't use the word "epilepsy," Margaret Warmack explains that Greg "would go into a seizure any time there was any kind of excitement, like if someone was fighting or arguing. He kept having them for several years, and by the time he was in about ninth grade it was happening so often that I took him out of school, and he didn't go back to school after that."

This would have been only a year or two after he saw the mysterious ball of light in his back yard, an experience that may or may not have been related to the seizures—which hadn't been Greg's only problem in school. An unusually sensitive child from a traditionally religious family, he had always carried a Bible with him to Englewood High School, and this practice drew the ridicule of some fellow students. **"The kids were all the time calling me 'Preacher,'"** he remembers. **"And one time there was this big guy who called me that and pushed me down in the mud and wanted me to fight him, but I wouldn't fight."** Interestingly enough, Greg's seizures stopped within

about a year of his exit from school. "He outgrew them," as his mother puts it, when he was about fifteen or sixteen years old.

Margaret Warmack is a devout Baptist, and it was from her that Greg inherited his early interest in the Bible. He notes that his maternal great grandfather, a great uncle, and a great aunt were ministers, while his maternal grandmother was an evangelist. As part of her own religious training, his mother had regularly heard and sung the gospel music that is a strong tradition in Chicago's African-American community. She in turn taught her children how to harmonize and sing hymns and spirituals, and in the late 1950s and early 1960s the entire family performed at churches in and around Chicago as the Warmack Singers. "We had the group for four or five years," she recalls, "but after that the older ones wanted to go their own different ways."

Warmack credits his mother with encouraging his artistic pursuits. In fact, the first piece he made for any kind of public display was one that she, in effect, commissioned—a sign announcing a celebration at the New Star of Bethlehem Baptist Church, where the family attended Sunday services. **"Making that sign was what really got me started making things for other people,"** Warmack says. **"After that, anytime there was any kind of special event at the church, I would make a sign and paint pictures of angels and clouds on it. Then I just started painting lots of pictures and giving them away to people. I would cut up old boxes and paint on those or just use anything I could find."** The subjects of his artworks varied widely. "One time when he was still pretty young," his mother remembers, "he drew a picture of an el-train wreck, and not long afterward there was a wreck on the el downtown that looked just like the one he drew. It was like he saw it before it happened."

In addition to his creative talent, Warmack showed an early propensity for collecting things. His mother recalls, "Anytime he would find certain kinds of rocks or anything else that looked old, he'd pick it up and carry it home." By the time he was in his late

teens, his accumulations were presenting storage problems. **"I had so much stuff in my room,"** he says, **"there was nowhere to lie down, so at night I would sleep under the kitchen table."** It was finding a hoard of beads and jewelry thrown out by a neighbor that stimulated Warmack's interest in making earrings and decorative pins. This was soon after he left school, and at the time he knew a neighbor named Keo who made earrings in a small shop on 63rd Street. **"I had watched Keo working, so when I found all these jewelry parts I went over there and he showed me how I could make earrings out of them. After that, I started going to resale shops and buying bags of old jewelry for three dollars a bag. Then I would separate all the pieces and use the parts with other things I'd find to make my own jewelry."**

This was only one of the varied creative activities with which Warmack occupied himself during his teens and into his twenties. He continued to paint on cardboard and even began producing a series of painted rocks. He collected tree bark, which he carved to form **"little faces that looked like African masks or tikis"** and hung on string necklaces. He also made dashikis, wooden canes with carved faces, and hats decorated with rhinestones and other ornamental items. Warmack managed to do all these things despite the many physically demanding jobs he took to help support his family after leaving school. In the fifteen years before the assault on May Street, he was employed as a newspaper carrier, waiter, busboy, dishwasher, cook, hairdresser, salesman, window-display designer, record-store clerk, masonry repairman, and furniture upholsterer.

Warmack's nights of sleeping under the kitchen table ended when he converted the small basement below the family's 61st Street apartment into a combination bedroom and studio. **"It was real, real damp down there,"** he remembers, **"and rats used to run across my bed at night, but I had more privacy and more room to work. My room upstairs was so overcrowded with stuff, but down there in the basement I had room for a workbench and lots of**

shelves to hold my beads and earring parts and all the things I was working on." Unfortunately, the landlord discovered Warmack's subterranean hideaway and made an issue of the local building code's prohibition against occupying an unfinished basement. Forced to vacate the space, Warmack moved his workbench, tools, and materials onto the back porch, where his activities soon aroused the curiosity of neighborhood children. "This was an area where there were lots of kids who didn't have anything to do," he explains. "So I would always give them something to do. They would come over and sit on the porch and make artwork with me. I would give them pieces of mat-board that I had found and cut-up boxes to draw on, and I shared my paint with them." Warmack became a kind of Pied Piper for these children, who had apparently identified him as the most interesting adult—or quasi-adult—in their realm. Over the next several years, as long as he remained in the neighborhood, they continued to seek him out, learn from him, and take advantage of his generosity with his meager art supplies.

What the artist refers to as his first show was a one-day event he organized with his young students in a lot on 61st Street, approximately a decade before his first formal gallery exhibition. It was the early 1970s, and he had recently moved out of the family's apartment on that same block, but only as far away as next door, and he was still using his mother's porch for his informal art classes. "I roped off this vacant lot with red, white, and blue ribbons," he remembers, "and I got the alderman to come over and cut the ribbon across the sidewalk, like a grand opening." Warmack displayed examples of his painted rocks, carved canes, and miniature tree-bark masks, and his young friends showed their drawings, paintings, and various other things they had made under his loose supervision. Nothing was for sale. The idea was simply to show the community what they had created in their spare time.

This art show and his artmaking sessions with neighborhood children prefigured the formal work-shops Mr. Imagination would conduct in Chicago schools and elsewhere after he became more widely known. But for the rest of the 1970s, Warmack remained a relatively anonymous street artist whose audience consisted almost exclusively of bar patrons and the kids who roamed his neighborhood. His near-fatal encounter in 1978 did nothing to change that. About a week before the shooting, however, Warmack remembers having two premonitions. The first was strange but not unpleasant. "I was standing in the washroom at my mother's house," he says, "and I looked in the mirror, and I had a flash of seeing myself in a regal outfit with a crown or some type of headdress on. I looked like a king." The second experience, by contrast, was highly disturbing. "I was sitting at the kitchen table one day, and all of a sudden this cold chill came over my body. And it was like a little voice spoke to me, and it told me someone was going to try to kill me. I started crying, and my youngest sister, Valeria, asked me what was wrong, so I told her."

Not many days later, Warmack lay unconscious in St. Bernard Hospital, connected by tubes and wires to machines that fed him glucose and monitored his vital signs. From his own perspective, he was traveling through a tunnel of light, but to his family and the hospital staff he appeared comatose, suspended in a condition of physical stasis. He would remain in that state for a month and a half. Warmack's description of what he felt during surgery coincides with accounts of individuals who report "near-death experiences." These typically begin with a sensation of leaving the physical body, at which point "the patient undergoes a complete change of perspective. He feels himself rising up and viewing his own body below." Those who have traveled to the brink of death also often describe going through "a portal or tunnel" and entering "a brilliant light."[4]

Warmack's account is unique on at least one key point. "I don't exactly know how to explain it," he admits, "but while I was going through this bright light I had the feeling that I was traveling back into the past. I don't know how far I went or how I was traveling—if I was walking or floating or what—but I

know that I had left my body and went through some kind of tunnel. And wherever I was, it seemed like the air was nice and fresh, and I didn't feel any pain or anything. But it wasn't like I could remember anything that I saw after I came out of the coma. The only thing I really remember seeing is just this glowing light." According to the legend that has grown up around Mr. Imagination, while in a coma "he experienced a vision of himself as an Egyptian pharaoh and several African kings." Or, as one reporter put it, "He dreamed he traveled back in time to ancient Egypt, and when he awoke he began turning the images from his coma into art." Another writer tells us that "when he woke from a coma," he "changed his name, and declared himself an artist."[5]

But again, the real story appears to be more complicated. "All I can remember about coming out of the coma," he says, "is that this beam of light I had been traveling through started to get smaller, and finally it got really small and moved over into a corner of the room. And for a minute I could see a little cross in it, but then it just disappeared, the cross and the light. And I don't remember this, but I was told that when I was coming to, I pulled the tube out of my mouth and just started pulling out all these tubes and things they had me hooked up to." After regaining consciousness, Warmack was in no shape to think about changing his name, making art, or doing much of anything else except waiting for his shattered body and wounded psyche to heal.

"For about three or four or five months I stayed with my mother," he recalls, "and at first I couldn't talk, so she gave me these sheets of brown paper to write on. My writing looked like a little kid's writing, so I had to learn to write all over again. And I really couldn't walk for a long time. I had to stay in bed, and I had a little bell that I would ring if I needed anything. And even after I got out of the hospital I was always constantly smelling blood. I was afraid to go outside for two months. But

then this friend named C. A. Swopes, who lived in the neighborhood, he gave me the encouragement to come back outside, and he was actually the one who gave me a cane to walk with. So for several months I had to walk with a cane, and I couldn't stand up straight. I was walking totally bent over, and sometimes it would take me like a half-hour to walk just two blocks. I don't remember making any art during this time after I got shot. Not for a while."

Eventually, though, as his health and strength returned, Warmack resumed his artmaking activities. Within about a year of his brush with death, he was once again entertaining children with his seemingly magical artistic skills. "My aunt, Alfreda Jones, had been kind enough to let me move into a room at her house at 62nd and Ada Street, and right next door to her apartment was a vacant lot that had a big old tree right in the middle of it that was half dead and half alive. So I cleaned up that lot and kept the weeds out, and I found some old railroad ties where they'd torn up part of the el-train track. I got some of the stronger kids in the neighborhood to help me move them over there and used them to block off the lot, and I started doing workshops. On very hot days, I'd sit up under that tree and make miniature houses out of cardboard. They were like these little churches that my grandmother used to make when I was a little bitty kid, out of box cardboard and milk cartons that she painted and decorated. And in this area where my aunt lived there were lots of kids everywhere, and they were so curious about what I was doing that they'd just come and sit and watch me make things."

It was at this time, probably in 1978 or 1980, that Warmack made a discovery that led to an important new phase in his artistic development. "I was walking to the store one day when I saw a truck dumping some unusual material into a vacant lot. I was very curious to know what it was, so I went over to look closer,

and it looked like some kind of big rocks. But when I was on the way back from the store, the truck was gone and the lot was leveled. A bulldozer had gone over it and crunched up the top layer, but I could tell there were still some big chunks of it under the surface, so I pulled out a couple of them and brought them home with me. At the time I was working on a miniature cardboard house, and instead of painting the roof on it, I put glue on and rubbed these two pieces of stone over it so that sand came off and stuck to the roof. And while I was rubbing these rocks together, **I noticed that each one was forming a certain shape** from the way it was rubbed, because they were very soft rocks. Then, searching for a sharp instrument, I found a nail and carved my initials into one of them, and that's when I had a huge brainstorm. I said to myself, 'Wow! I've found a hidden treasure that the man of the eighties doesn't even know exists!'"

Warmack's uniquely attuned sensibilities and his resourcefulness, a habit learned from a lifetime on the economic fringe, enabled him to see "hidden treasure" in what anyone else would have considered trash. What he had found was a load of industrial sandstone, compact clumps of sand which the steel industry generates as a waste by-product and disposes of in places like south-side Chicago. Realizing he could use the substance as a sculptural medium, Warmack began literally mining this cache of free material. **"I would take a grocery cart and a shovel and go down there to that lot early in the morning and dig out these big blocks of sandstone. There were some guys who lived a few doors away who would laugh at me when they saw me out there digging up the ground and carrying off these big blocks in that grocery cart. They'd ask me if I was going to plant a garden with all that dirt I was hauling away. And lots of times when I'd go to the store or be out walking somewhere I would carry a piece of sandstone with me, and I'd carve on it as I walked. People laughed at me for that. They'd tell me I must be**

crazy if I thought I was going to sell any of the things I was making. They'd laugh and laugh, but I never did care about anybody laughing at me. Later on, when people started to see what I was doing, the laughter stopped."

Then as now, Warmack routinely stayed up all night working on his art, and often as he busied himself into the wee hours, he would see suggestive hints of imagery in the craggy contours and varied color gradations of the sandstone even before he began manipulating it. **"I was having a lot of migraine headaches around this time,"** he says, **"and carving the sandstone would make them go away. I would just start meditating into the sandstone, and the headaches would gradually just go away. And I would start seeing my own face and lots of other faces and images in the sandstone. It was like the images were there before I even started carving them, and it was up to me to remove the sand from around their faces. And this feeling would hit me that was like the feeling I had when I looked in that mirror and saw myself as a king, or when I was traveling back in the past in my coma. And it seemed like all these things I was seeing were connected to ancient civilizations. It's really hard to explain it, but it was as if all these images were coming out of the same place I had gone to when I was in a coma. I can't explain it in words. I can only explain it with my art."**

No sooner did Warmack discover this new medium than he immediately began sharing it with the neighborhood children. **"I got three old doors that had been thrown out in an alley and laid them down in a U-shape on top of some railroad ties under that tree in the vacant lot next door, and I'd sit out there and work on the sandstone, and all these kids would come over. I was out there just about every day, and some parents would bring their kids by and leave them, and they'd stay all day. It got to where I was baby-sitting the whole neighborhood. And**

I remember there was this one kid who didn't live there, but he had friends in the area. He was a bad kid who was always getting in trouble, but he was so fascinated with the sandstone that he'd walk all the way from the projects over on State Street and stay all day. There were some other kids who were very poor, and after they'd been coming over and watching me work, they taught their mother how to carve things from sandstone, and they would go down to Maxwell Street and sell some of the art they made to help pay their bills.

"I became the hero of the neighborhood. Somebody told me that Operation PUSH should come to see what I was doing with these kids, but I didn't know how to get in touch with them, and besides, I never wanted to get involved in politics. I did call a few newspapers to come see what we were doing, but they didn't know anything about me, and they didn't really even listen to me. But I just continued to do my workshops. One day when I was out there with the kids working on sandstone, this old guy walked up and looked at what we were doing, and he told me I was ahead of my time. I had made an ashtray that he liked out of sandstone, and I told him he could have it. He gave me a dollar, and I tried to give it back to him, but he made me keep it. He said one day I was going to be a famous artist."

Intently absorbed in his creative process and content with the respect it earned him in his community, Warmack was nevertheless also quietly aware that he lived on the margins of a culture that occasionally rewards its artists with exhibitions, media attention, and a decent living from the sale of their work. So, when this appreciative stranger predicted future fame for him, it reinforced a notion that had already crossed his mind. Nearly a decade earlier, an elderly neighbor had made a similar forecast. **"She told me,"** he recalls, **"that one of these days the whole neighborhood was going to know**

who I was, then the whole city would know me, and eventually the whole world." As early as the late 1960s, he had a feeling of confidence about his future as an artist: **"I knew I was going to become someone."**

It was perhaps with all this in mind that Warmack started calling himself "Mr. Imagination," sometime between 1979 and 1981, although his memory of the surrounding circumstances is fuzzy. **"I know I started using this name soon after I started working with the sandstone,"** he muses. **"I think it started when somebody told me I had a wild imagination and then called me Mr. Imagination, but I don't remember who it was."** Also around 1981, soon after the visitor to his vacant-lot workshop told him he was destined for fame, he made his most overt attempt yet to draw public attention to his creative endeavors. His earlier phone calls to the newspapers about his neighborhood sandstone workshop had gone ignored, he figured, because the people he spoke to hadn't been able to see with their own eyes what he could do. So he decided to put himself and his art in a position where they were sure to be seen by important local media representatives.

The largest and oddest piece he had made up to that point in his career was his *Prehistoric Alligator*, a long, horizontal sculpture created from a partly burned tree trunk he had found along 61st Street several years before he was shot. Conveniently attached to this creature's back was a wire handle Warmack employed to carry the piece on the el train. **"Everybody walks around with a dog on a leash,"** he says, **"so I thought, 'I'll be different. I'm going to walk around with a prehistoric alligator on a handle.' So lots of times I used to take that piece down to the Channel 7 offices at Lake and State Street and just walk by the place real slow, hoping someone in there would come out and put me on television. I got lots of attention. Cars would almost have accidents driving by because the drivers were looking at me instead of where they were going. Little kids would come by with their mothers**

Mr. Imagination with *Prehistoric Alligator,* 1993
(photo: Kevin Orth)

and say, 'Oooo, Mama, look!' And their mothers would yank them by the arm and get away from there as fast as they could. They didn't know what that thing was I was carrying around. They thought I was nuts, and I guess the people at Channel 7 did, too, because no one ever came out and put me on TV."

By this time, Mr. Imagination had moved from his aunt's place on 62nd Street and into a building on 61st near Racine, where two of his brothers were also living. There he continued to refine his sandstone-carving technique and displayed some of the more elaborate sculptures in an interior environment which included hundreds of other objects he had made or found. **"I would always turn every place I ever lived in into a shrine,"** he says. In early 1982, he found a less expensive apartment several blocks away at 58th and Union, and in March he began moving in. Since he didn't have access to a car and then, as now, didn't know how to drive, he had to transfer his belongings by hand and on foot. He was well into this process when he arrived at his old place on 30 March 1982—his thirty-fourth birthday—to find it gutted by a fire that had also damaged his brother's apartment upstairs. Next to the shooting, this was the most traumatic experience he had ever endured.

"I still had so much of my work there," he wistfully recalls. **"There was lots of my art, and all of my notes and some clothes and other things. By the time I got to the apartment that day, the fire trucks had already been there and left. The doors were knocked down, and everything was still wet from the fire hoses. You could still smell the smoke. When I saw the place, I was devastated. I fell down on my knees and started crying, and I said, 'Why would anyone do this?'"** Given that the fire started in his absence, apparently originating in his apartment, he suspects it was arson but has no idea who was responsible. A number of his possessions survived the blaze, but some of these were evidently stolen before he arrived on the scene. **"I was told that someone in the neighborhood took lots**

**Native American
Head,**
1990, cat. no. 114

of my art," he says, "and built a shrine out of it in an empty building right there in the same part of town. I never did find out where the place was or who took all that work out of my apartment, but that's one thing that has always stayed on my mind ever since then."

Mr. I took what he could salvage from his torched crib over to 58th Street. **"I had a red carpet on the dining room floor in the new place,"** he remembers, **"and surrounding that I made an altar. I collected lots of bricks and laid them down to make a long aisle, and then I laid all my work on that red carpet. I had lots of sandstone heads—several of the ones with kinglike faces, and a sandstone Indian with white and black painted eyes. I had another sandstone piece that was a dog. I had carved the names of lots of celebrities in sandstone—Michael Jackson, Diana Ross, Lionel Richie, and lots of others—and they were there. I had the Prehistoric Alligator. I had moved some of these over to my new place before the fire, but some of them were partly burnt. The piece called <u>Time</u> is an alarm clock that got burned in that fire. All these pieces were set up in the dining room at my new apartment, and I had a sign just inside**

the door that said, **'Welcome to the World of Mr. Imagination.'"**

The apartment fire was a major setback in every respect, and Warmack acknowledges that it slowed him down for some time. But the dark smoke-cloud this personal disaster cast over his life turned out to have a silver lining of sorts. On his rounds with the *Prehistoric Alligator,* he had occasionally visited a north-side antique shop whose owner, Jeff Jones, suggested that local art dealer Carl Hammer might be interested in Mr. I's work. The artist contacted Hammer several months after the fire and invited him to come see his art. When the gallery owner paid his first visit to Mr. Imagination's 58th Street apartment and studio, he responded very strongly to the work—and was particularly drawn to the charred, smoke-damaged pieces that had been retrieved after the fire.

This was the break Warmack had been waiting for and in recent months actively seeking—the entree to public recognition which the busy folks at Channel 7 had failed to provide him. Hammer bought several pieces and immediately offered the artist a show, and on 4 October 1983, Mr. Imagination made his official art-world debut at the opening of his one-man exhibition. Prominently featured were those pieces damaged in the fire eighteen months earlier. This was the first of eight solo or group shows at Carl Hammer Gallery in which Warmack would participate over the next ten years, not to mention more than a dozen other museum and gallery exhibitions during the same period in New York, Philadelphia, Boston, San Francisco, Seattle, and Dallas, among other cities.

While it brought him increasing recognition in the art world, Mr. Imagination's new association with a downtown gallery didn't divert him from his long-established routine as a wandering street artisan. For several more years, he continued to make his rounds in local bars. **"I'd carry my bag of sandstone around on my shoulder, and I'd walk into a bar and introduce myself to the bartender and whoever else was there. I'd always make a little sandstone sign with the name of the bar on it, and I'd give that**

to them. Then anyone who wanted me to make a sign for them would tell me their names and I'd make one for them right on the spot." The lettering on these personalized sculptures resembled the compact, fluid, psychedelic script used on rock-concert posters during the late 1960s. **"Usually I would just charge five dollars [for them],"** Warmack recalls, **"unless someone wanted something big or special, like a valentine with two names on it or whatever. Then I would maybe charge ten dollars."** Evidence of Mr. I's skill with a block of sandstone and an ordinary nail can today be found in taverns, nightclubs, and restaurants all over Chicago.

Nor was his interest in working with children curtailed by his art-world successes. On the contrary, his new status led to increasing numbers of invitations for him to conduct workshops in Chicago schools. To this day, he continues to accept dozens of such invitations in and beyond the city every year, and he never tires of playing the role of gently inspirational mentor to art-inclined youngsters who respond enthusiastically to his signature directive— **"Just use your imagination."**

Between earnings from his bar-circuit novelties, occasional gallery sales of his more ambitious sculpture, and visiting-artist fees, Mr. Imagination was soon able to afford a level of stability in his living situation which he hadn't known since childhood. After years of bouncing around from one over-priced tenement to another on both the North and South Sides, by 1985 he moved into the modest five-room apartment where he still lives and works almost a decade later. Meanwhile, his art continued to evolve as it had for more than thirty years. His sandstone pieces became more complex, sophisticated, and sculptural. He began working with larger blocks of his favored material and creating more in-the-round works in addition to wall reliefs like those he had been producing for some time.

In this connection, it is perhaps worth mentioning an intriguing coincidence that came to light around this time. Not long after he began exhibiting at Carl Hammer Gallery, Mr. I learned of another self-taught African-American artist, Lonnie "Sandman" Holley of Birmingham, Alabama, who had independently discovered the possibilities of industrial sandstone as a sculptural medium. Holley had begun working with this discarded by-product of area steel mills in the late 1970s, around the same time Warmack found his stash of hidden sandstone "treasure" in a vacant south-side lot. Like his Chicago counterpart, Holley is an obsessively prolific artist who also enjoys conducting art workshops for children, and his own work in sandstone bears uncanny similarities to Mr. I's in both form and content.[6]

In the late 1980s, a series of fortuitous breakthroughs opened up new material possibilities for Mr. Imagination. In 1988, Lisa Stone, then director of Carl Hammer Gallery, gave the artist "buckets and buckets" of beer-bottle caps which her brother had collected for years but finally decided to toss out. Warmack immediately, as she says, "started making incredible things out of these bottle caps." He had seen the generic folk-craft dolls whose arms and legs are comprised of several dozen bottle caps stacked and tightly strung like beads on stiff wires, so he employed this technique and others of his own devising to create a variety of structures and patterns that he used in typically ingenious ways. **"The first thing I did with the bottle caps Lisa gave me was to make a coat out of them for a Halloween party,"** he recalls. **"Then I made a bottle-cap hat and a bottle-cap mask and a bottle-cap staff, and I wore them all to this party, and there were prizes for the best costume. And you know what? I won the first prize for my bottle-cap costume."**

He followed these idiosyncratic raiments and accessories with other utilitarian pieces made of bottle caps—neckties, a chair, a large picture frame, a velvet-cushioned throne—and he eventually found other uses for this readily available material, attaching rows or clusters of bottle caps to sculptural pieces as a way of giving them flash or creating rhythmically repetitive tactile and visual effects. Contrasting this process with that of carving his sandstone sculptures, he says, **"With the**

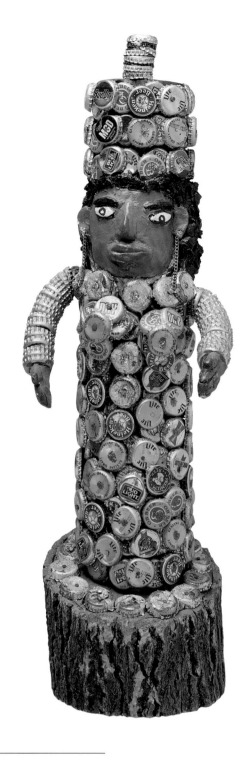

Log Woman,
1990, cat. no. 110

sandstone I have to take away from what's already there. With the bottle caps I put one on, then another, and I just keep adding to what's there, instead of taking away."

For Mr. I, something about this additive process is seductive in itself, generating an apparently trance-like state. **"Working with bottle caps makes me feel good,"** he says. **"And sometimes once I get started doing it, it's hard to stop. It's the same thing with nails. I love putting nails in things. One time I was using some nails to make something, and I started hammering nails into this piece of wood, and I just kept on constantly doing it, putting more and more nails in it, for a long time. I don't know why. It made me feel relaxed, and it was hard to stop. Later I was looking at a piece of African art in a book. It was called a fetish, and it had nails all in it, just like what I had done."**

Indeed, Mr. I's use of nails and bottle caps, like the trans-temporal visions he experienced while sculpting industrial sandstone, seem to support the concept of an unconsciously transmitted African-American "atavistic aesthetic," as promoted a quarter-century ago by Chicago's AFRI-COBRA artists.[7] And curiously, unbeknownst to Mr. I, the academically trained artist David Hammons had already been working with bottle caps, among other materials found on the streets of New York's Harlem, for some years. In a 1981 interview, Hammons sounds remarkably like his self-taught Chicago counterpart: "Working the way I do, collecting stuff and letting it build up around me, feels very good. I can't do any wrong. The objects find each other. It all flows together and that feels very fine. I like the energy of used things. I like my objects to have spirit already in them."[8]

Mr. Imagination soon exhausted his initial supply of bottle caps but continued collecting them on his wanderings about the city, enlisting the help of his bartender friends. He never runs out. About a year after he began working with bottle caps, however, Mr. Imagination made a discovery that led to yet another series of works created from used and discarded materials. **"I had all these paint-**

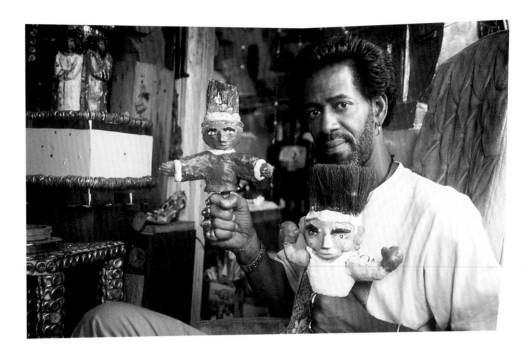

Mr. Imagination with "paintbrush people," 1993
(photo: Tom Patterson)

brushes that weren't any good anymore,"
he explains. **"The bristles were all worn down
and stuck together, but I didn't throw
them out. Then one day it was like all of a
sudden this face just appeared on one of
these paintbrushes while I was looking at
it. So I took a little plaster of Paris and
some paint, and I made that face on there."**
As with the bottle caps, nails, and sandstone, once
he made his first few **"paintbrush people,"** as
he calls them, he was hooked on the process—and
in this case, the image, too—and he **"kept con-
stantly doing it."**

He hasn't kept track of how many he has made, but
he's sure there are hundreds. They look like little
masks, all featuring the same bearded, dark-skinned
face, above which the stiff bristles serve as hair.
Each one is essentially a self-portrait modified to
include a tall crew cut. The paintbrush handles serve
as elongated necks or abbreviated bodies for these
startlingly animated-looking characters with their
benignly staring eyes. Some of the paintbrush
figures are more elaborate than others, more brightly
painted, fitted out with fancy headdresses made
from bottle caps and other found objects, or with
more fully articulated bodies. As with many of the
faces he has carved from sandstone, the more regal-
looking paintbrush people recall the fleeting vision
of himself as a king that he first saw in a mirror days

before his brush with death. But others lack these
emblems of royal authority, and either depict some-
one other than the artist, or the artist himself in
various imagined roles. One figure, for example, is a
boxer, with hand-molded wood-putty arms attached
to the handle-torso and ending in a tiny pair of
boxing gloves. Another is a woman holding a much
smaller paintbrush baby in her wood-putty arms.
Expanding this basic motif to a larger scale, Mr. I
eventually began making similar alterations and
additions to old brooms, creating pieces that com-
bine characteristics of his paintbrush people with
the format of the bottle-cap staffs he had also been
making for a while. Thus were born the **"broom
people,"** of which there are now several dozen.

In late 1992, Mr. Imagination commenced work on
his latest series, this one consisting of **"totem
poles"** made by applying wood putty and attaching
bottle caps and other found objects to cardboard
cylinders of the kind on which paper is rolled for
storage and shipping. Mr. I began creating these
after he found several such tubes discarded in an
alley near his apartment, and they are his most
elaborate and profusely festooned works yet.
Ranging from three to nine feet tall, they typically
consist of multiple variations on the regal-looking
self-portrait image that can be seen in many of the
paintbrush figures and sandstone pieces, here
stacked one atop the other, all wearing the same

serenely expressionless gaze. These sculptures have in turn inspired him to invent new variations which incorporate other already familiar materials, and in 1993 he produced a small **"paintbrush totem"** and several **"broom totems"** centering around stacked examples of his broom and paintbrush people.

And so, on he goes, reworking his favored themes and subjects, discovering ever new and more imaginative means of exploring and presenting them. Mr. Imagination's knack for finding original ways of using cast-off materials promises to keep serving him well, particularly in such a junk-generating society as ours. He has recently started incorporating smashed aluminum cans into his work, and is currently fascinated by the innards of his old TV set— one, no doubt, of hundreds of such worn-out appliances discarded every day in Chicago. Having disassembled it, he is using its tiny bulbs and tubes as jewellike attachments on some of his new totems and paintbrush people.

"I like to make my art out of things I've found," says Mr. I, **"because they're there and they're free. When I'm walking through the alleys and on the streets, my eyes are always moving like a radar, looking for anything that I might be able to use. Sometimes it's like these things call out to me so that I'll notice them, or something will just appear in front of me, like this old wagon wheel I found in the alley by my place just the other day."** The artist's acuity as a scavenger is rooted in his childhood penchant for collecting and in the frugal habits he learned early on as an essential survival skill. He shares the attitude concisely summarized more than a decade ago by another self-taught artist of humble origins, the late Nellie Mae Rowe of Vinings, Georgia: "When other peoples have somethin' they don't know what to do with, they throw it away. But not me. I'm gonna make somethin' out of it."[9] The scavenging aspect of Mr. I's work, and his increasing emphasis on it through the use of multiple types of cast-off materials within a single sculpture, also reflects the growing ecological awareness that he shares with millions of fellow artists and other citizens of this country and the world.

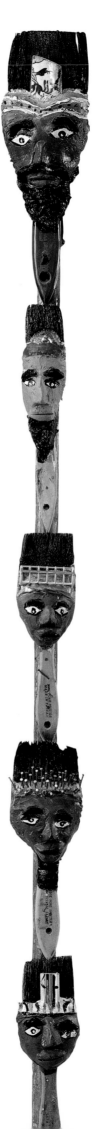

Broomstick with Paintbrushes, 1991, cat. no. 122

Ecological objects lessons, meditations on immortality and self-identity, assertions of joyous pride in black culture—as richly complex as his work is, Mr. Imagination's main aim in creating it is simple and straightforward: in his words, **"to make people happy."** In this respect, he is like the Buddhist devotee who vows daily to relieve the suffering of his fellow beings, and his work as an artist is a form of compassion in action. While he doesn't exhibit the aggressive evangelistic fervor of Howard Finster, Gertrude Morgan, or certain other spiritually motivated self-taught artists, there is no question that he sees art as an ultimately spiritual vocation. **"Years ago my great aunt predicted I was going to be a minister,"** he says. **"And in a way she was right. I'm a minister through my art. I pass messages on to people with my work. I think every artist is a minister and a messenger in a way. I work with kids, and I try to pull family members together. People that have problems come to talk with me about them, and I try to make them feel better."**

Mr. I's desire to be a positive, healing force within his community and the world is in large part a product of his religious upbringing, but it has been strongly reinforced by his experiences with intense pain, suffering, and loss. As he says, **"People who have near-death experiences like I did when I got shot, they have special things to do."**

As he makes that observation, the artist stands at a work table in his studio, attending to the details of his latest project while he talks. Peering out from shelves and window sills and walls are scores of his paintbrush figures, totem heads, and sandstone faces. They all wear the same clear, bright, open-eyed expression, the exalted gaze of one who has been to the cosmic edge and traveled through an unspeakable brilliant light to who-knows-where before returning to ordinary waking reality. Each eye of every one of these figures and faces stands for Mr. Imagination, intuitively creative urban mystic and non-sectarian minister, who just can't stop delivering these singularly uplifting, visually dazzling messages.

Notes

1. Roger Cardinal, "Figures and Faces in Outsider Art," in *Portraits from the Outside: Figurative Expression in Outsider Art* (New York: Groegfeax Publishing, 1990), 28.

2. All quotations from Gregory Warmack/Mr. Imagination are from the author's interviews with the artist in Chicago on 23 July and 16 October 1993, or via telephone on 12, 15, 17, and 28 December 1993, and 2, 3, and 9 January 1994.

3. Biographical information is drawn from the author's interviews with Mr. Imagination's brother William Warmack, 23 July 1993; by phone with their mother, Margaret Warmack (now residing in Merced, Calif.), 11 and 21 December 1993; with the artist's dealer, Carl Hammer, on 21 July and 14 October 1993, and 11 January 1994; and with the artist's friends Lisa Stone and Don McClory, 15 and 17 December 1993, respectively.

4. Raymond A. Moody, Jr., *The Light Beyond* (New York: Bantam Books, 1988), 8, 9.

5. Printed handout from the Visiting Artist Program, Department of Fine Arts, University of Colorado at Boulder, promoting a visit to the university by Mr. Imagination, 16-20 November 1992; Hilary Saperstein, "Mr. Imagination Transforms Items into Art Forms," *State Journal Register* (Springfield, Ill.), 24 January 1992; Mark Jannot, "Outside In," *Chicago,* July 1992, 80.

6. For more information on Lonnie Holley, see Judith McWillie, "Lonnie Holley's Moves," *Artforum* 30:8 (April 1992): 81-84; Tom Patterson, *Àshe: Improvisation and Recycling in African-American Visionary Art* (Winston-Salem: Diggs Gallery, Winston-Salem State University, 1993), 21, 31; and idem, *Not by Luck: Self-Taught Artists in the American South* (Milford, N.J.: Lynne Ingram Southern Folk Art, 1993), 8-9.

7. Nubia Kai, "AFRICOBRA Universal Aesthetics," in *AFRICOBRA: The First Twenty Years* (Atlanta: Nexus Contemporary Arts Center, 1990), 6.

8. David Hammons, interviewed by Guy Trebay, *Village Voice,* 29 April 1981, as cited in Lucy R. Lippard, *Mixed Blessings: New Art in a Multicultural America* (New York: Pantheon Books, 1990), 64.

9. Nellie Mae Rowe quoted in Tom Patterson, "A Strange and Beautiful World," *Brown's Guide to Georgia* 9:12 (December 1981): 53.

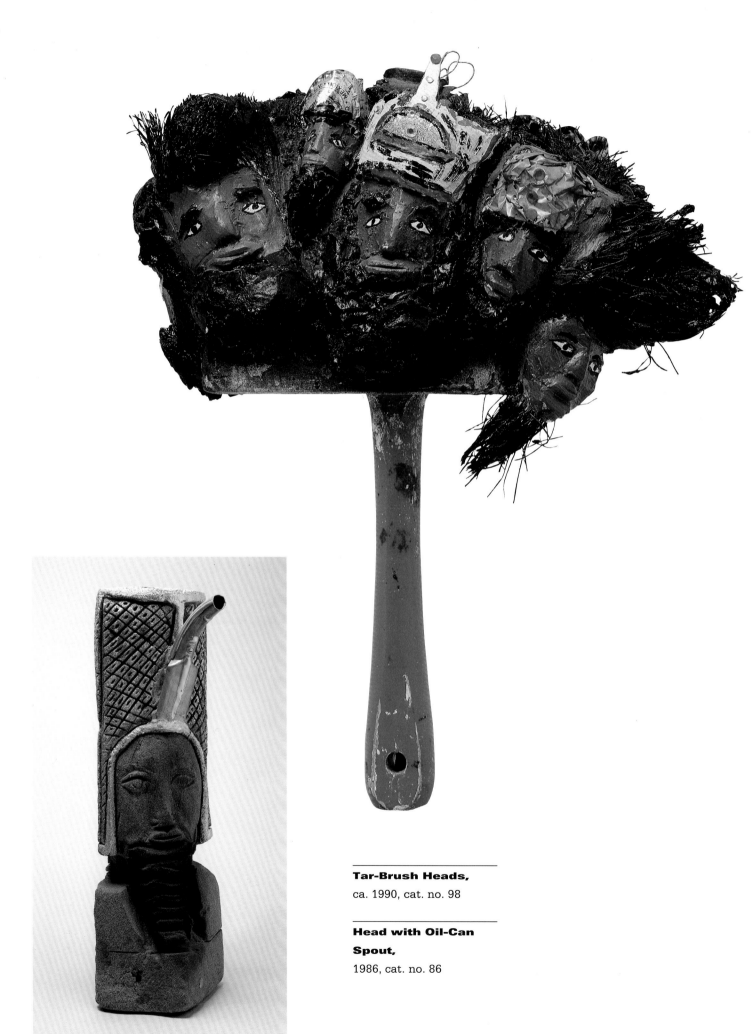

Tar-Brush Heads,
ca. 1990, cat. no. 98

Head with Oil-Can Spout,
1986, cat. no. 86

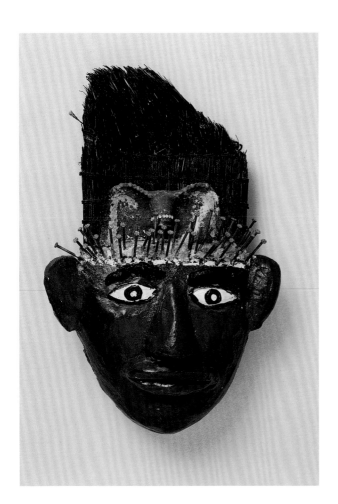

Broom Head,
1990, cat. no. 101

**Broom-Head
Self-Portrait,**
1992, cat. no. 147

**Cadillac Broom
Head,**
1990, cat. no. 103

Broom Head,
1992, cat. no. 144

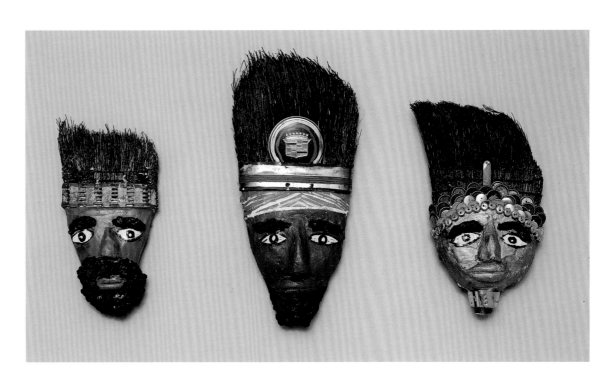

**Male Face with
Hubcap and Stove
Pipe,**
1990, cat. no. 111

**Female Face
with Bottle-Cap
Headdress,**
1990, cat. no. 105

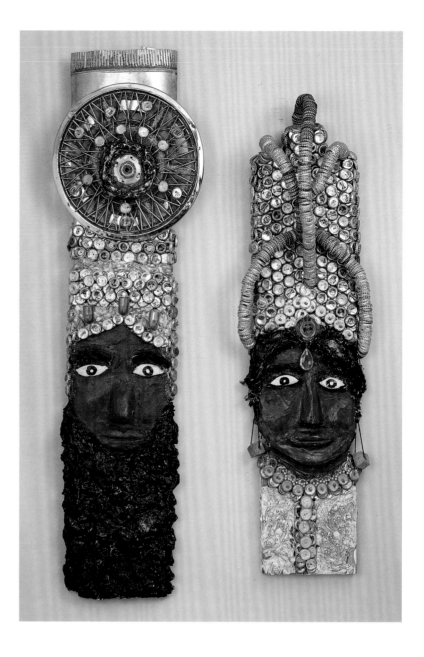

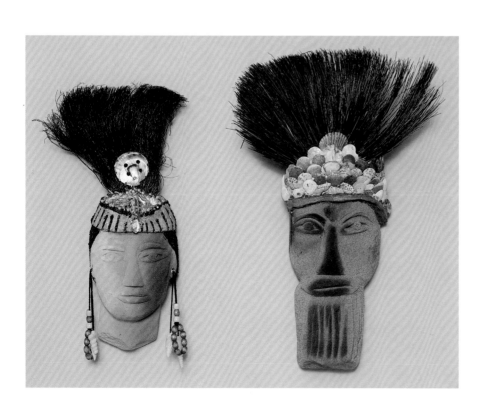

**Female Head
with Shell-and-Bead
Earrings,**
1990, cat. no. 106

**Male Head with
Shells,**
1991, cat. no. 130

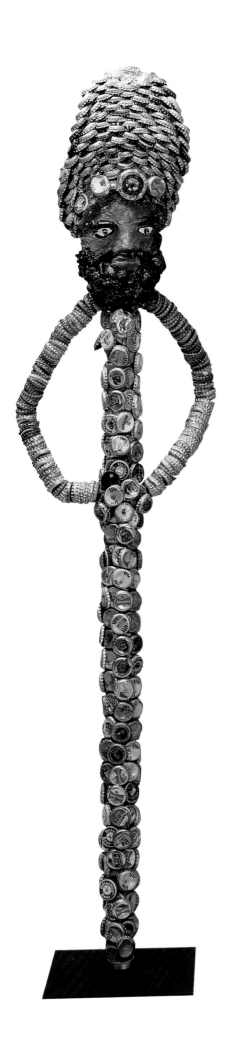

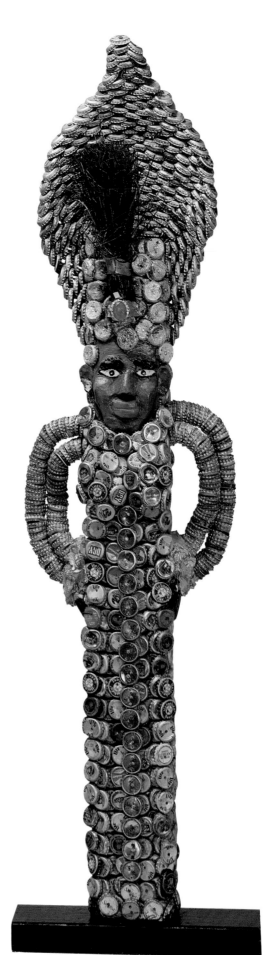

Male Bottle-Cap Staff,
1992, cat. no. 155

Female Bottle-Cap Figure,
1991, cat. no. 123

Mr. I,
1991, cat. no. 131

Rose,
1991, cat. no. 134

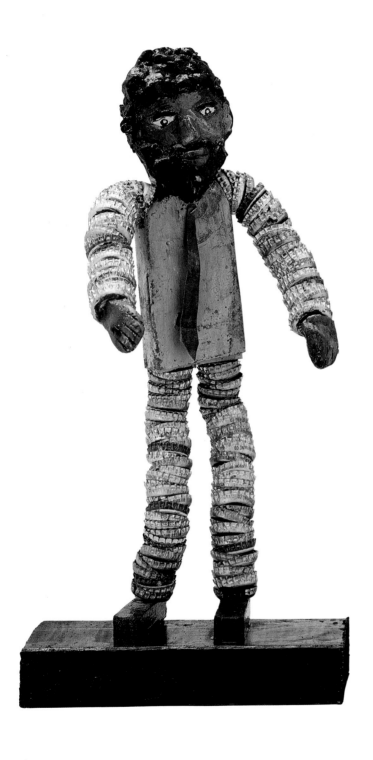

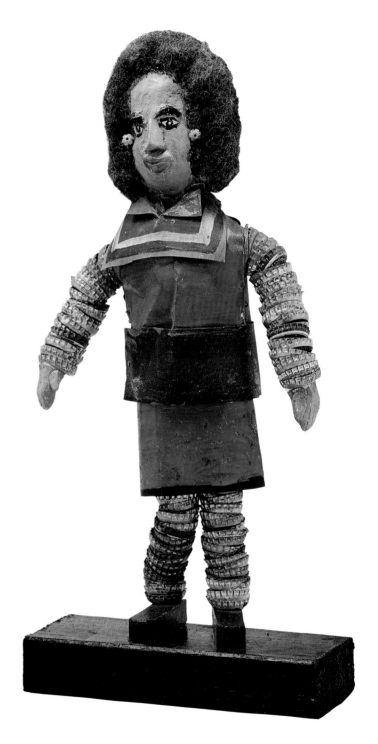

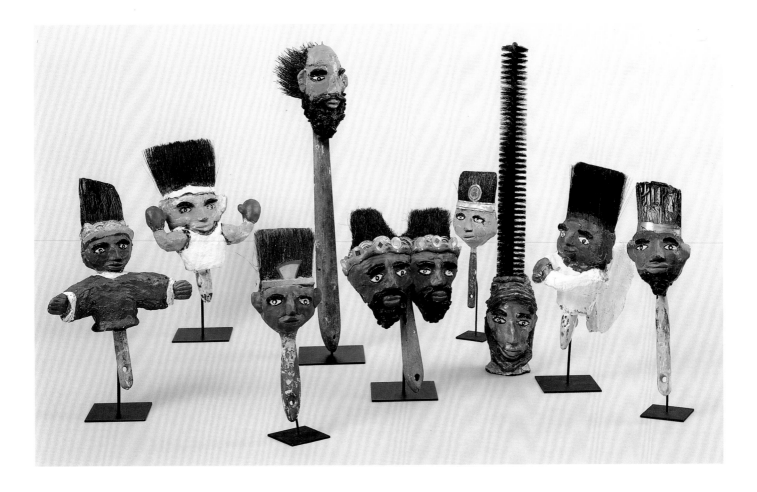

Paintbrush Figure,
1993, cat. no. 188

Boxer,
1992, cat. no. 143

Paintbrush,
1992, cat. no. 157

Scrub-Brush Head,
1991, cat. no. 135

Twins,
1993, cat. no. 194

Paintbrush with
Japanese Bottle Cap,
1991, cat. no. 132

Bottle-Brush Head,
ca. 1990, cat. no. 97

Angel Paintbrush,
1993, cat. no. 168

Paintbrush,
1992, cat. no. 160

"Keep This Coupon,"
1991, cat. no. 125

**Male Bottle-Cap
Figure with Cobra
Head,**
1992, cat. no. 153

Snake Woman,
1992, cat. no. 166

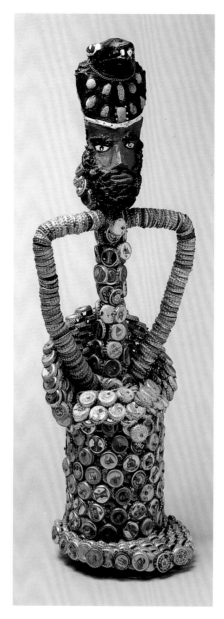

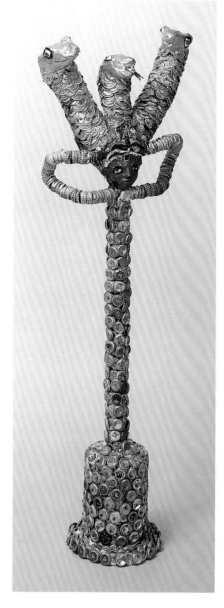

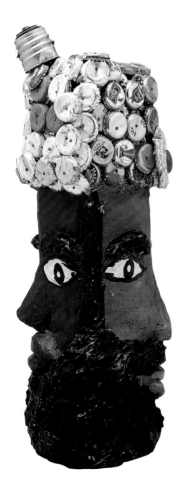

**Double-Faced
Self-Portrait,**
1992, cat. no. 150

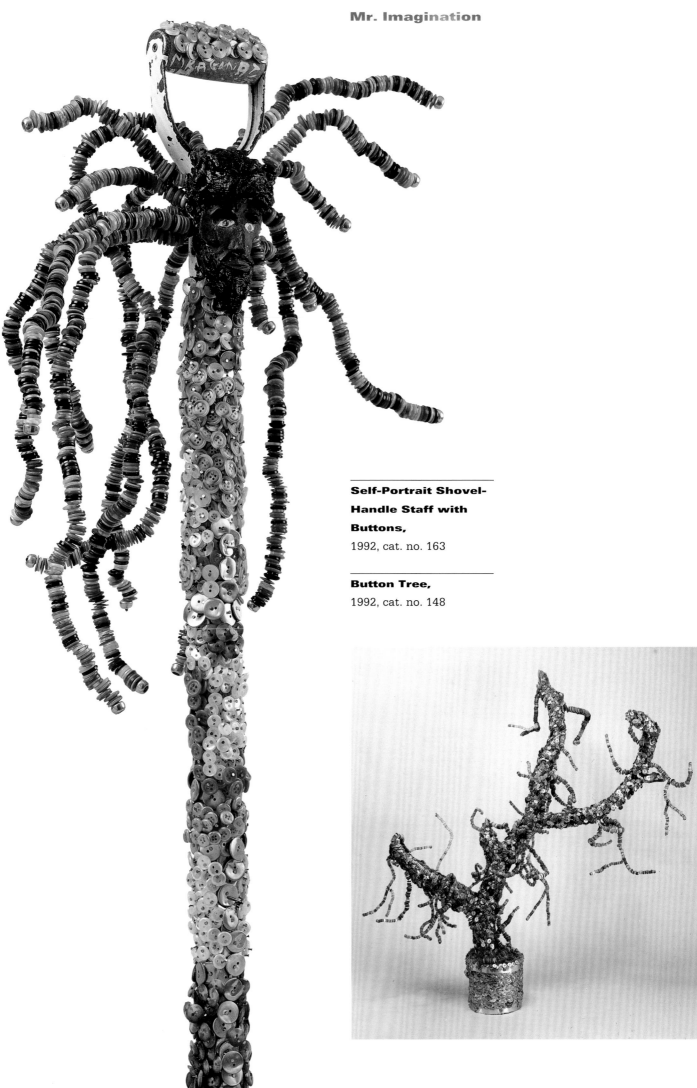

**Self-Portrait Shovel-
Handle Staff with
Buttons,**
1992, cat. no. 163

Button Tree,
1992, cat. no. 148

**Small Bottle-Cap
Fish,**
1991, cat. no. 137

**Small Bottle-Cap
Fish,**
1992, cat. no. 165

**Small Bottle-Cap
Fish,**
1992, cat. no. 164

Bass Instrument,

1993, cat. no. 169

Black Snake Staff,

ca. 1992, cat. no. 142

Black Cobra Staff,

1993, cat. no. 170

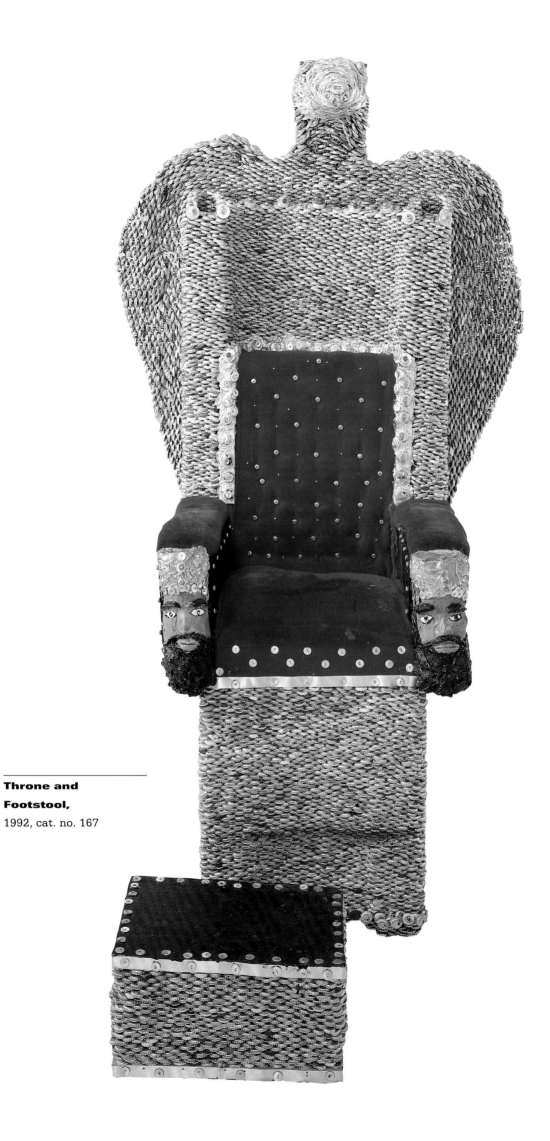

**Throne and
Footstool,**
1992, cat. no. 167

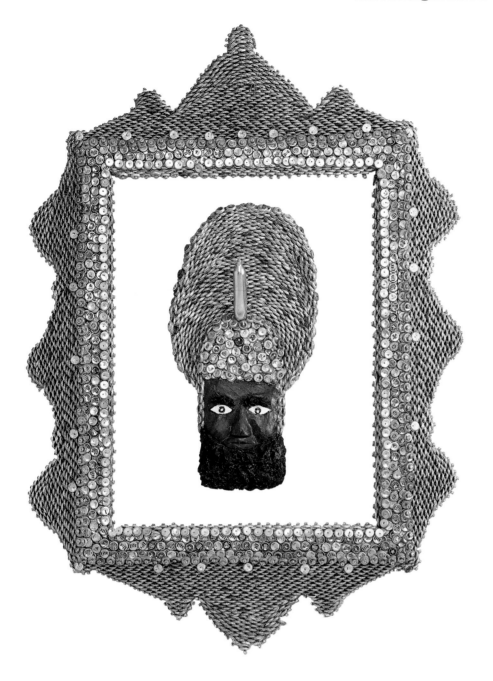

Bottle-Cap Frame,
1993, cat. no. 173

**Male Face with
Copper Cylinder,**
1991, cat. no. 128

**Bottle-Cap Shadow
Box with Self-
Portrait Paintbrush,**
1993, cat. no. 174

**Bottle-Cap Shadow
Box with Small
Paintbrush Head,**
1993, cat. no. 175

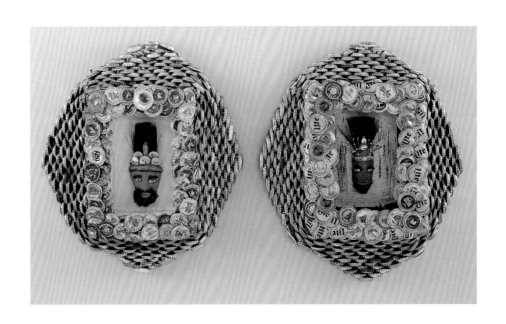

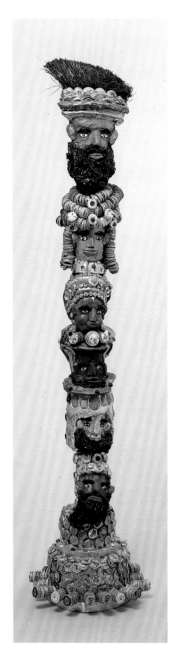

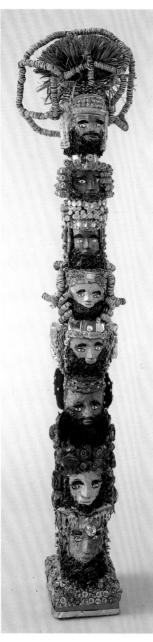

Six-Headed Totem,
1993, cat. no. 191

Eight-Headed Totem,
1993, cat. no. 178

Female Bottle-Cap Figure,
1993, cat. no. 179

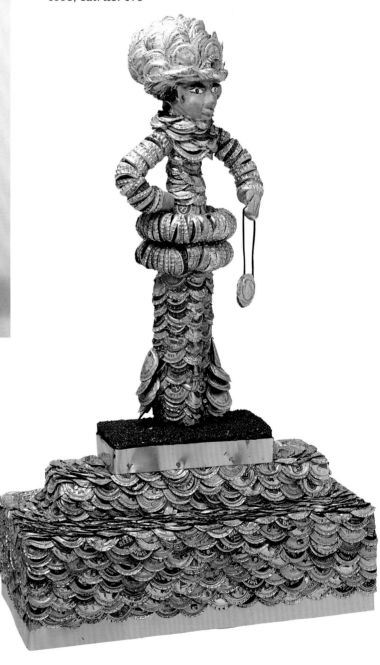

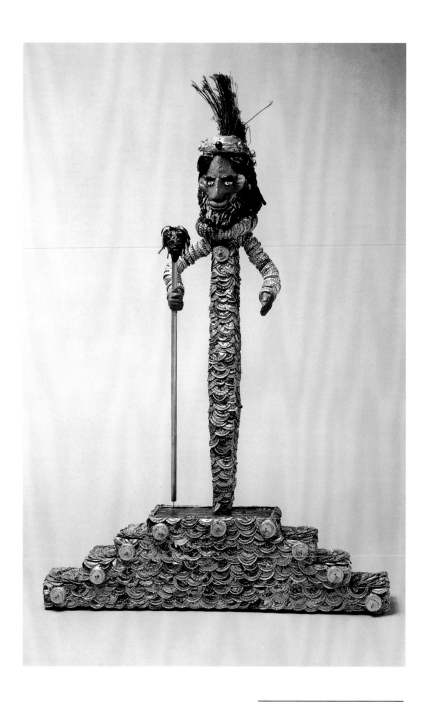

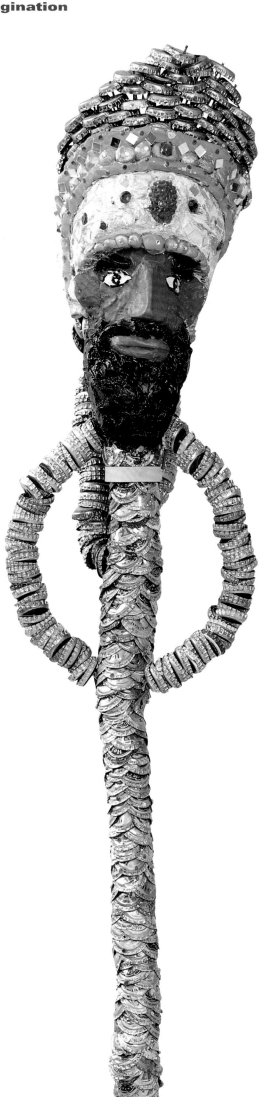

Male Bottle-Cap Figure with Staff,
1993, cat. no. 184

Royal Scepter Self-Portrait,
1993, cat. no. 189

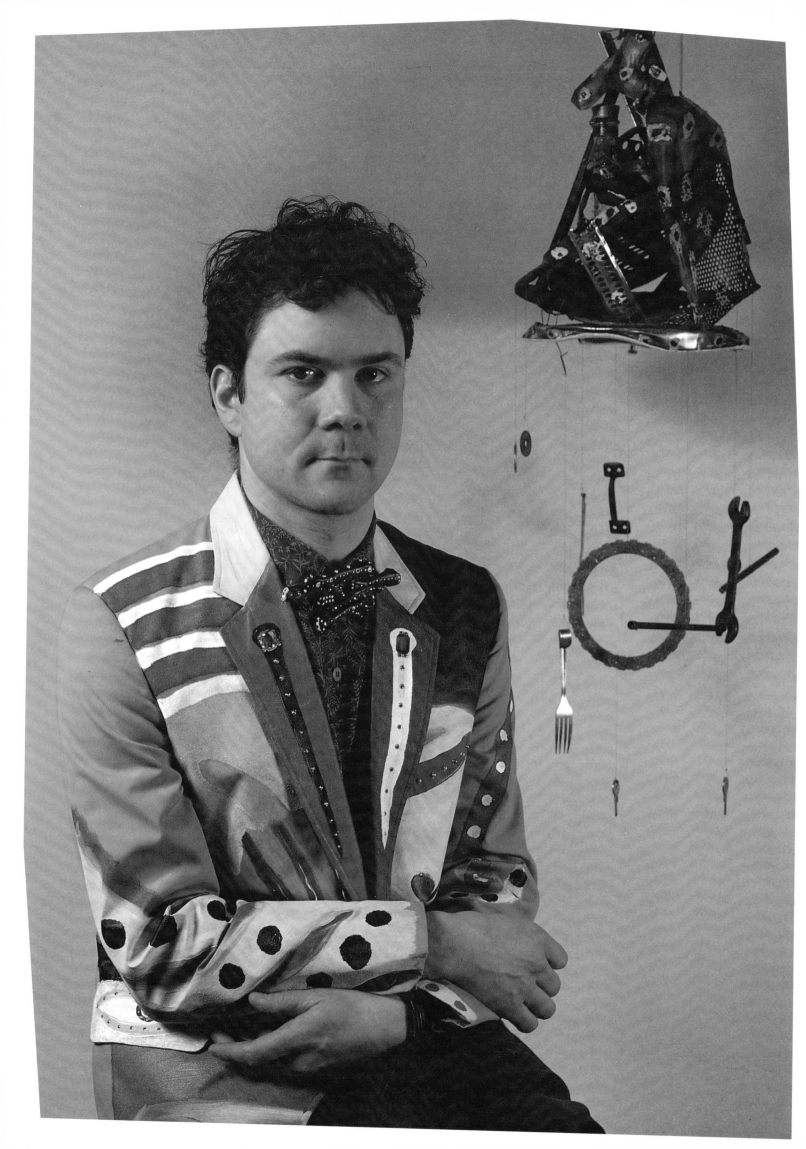

Kevin Orth's
Cathedral of the Dreams

Minor-key accordion music sounding vaguely like a tune on a broken calliope floats through a near-deserted section of the Clybourn Avenue district overlooking the Chicago River Turning Basin. The haunting chords that evaporate in the garbage-scented air over huge mounds of shredded upholstery along the river originate in a third-floor room at the rear of a nearby office-furniture warehouse. Sunlight streaming into that room gleams and flashes on the bright surfaces of over 175 elaborately modified glass bottles arranged on boxes, suitcases, and makeshift pedestals wedged symmetrically into a corner. Many of these bottles have been converted into doll-like figures with outstretched arms made of much smaller bottles and heads modeled from clay. Others have been combined with ordinary items such as light bulbs, flower pots, and jar lids to produce hybrid objects suggesting quirky abstract totems. And all of them have been painstakingly painted with intricate designs and stylized imagery in brilliant high-key colors.

These motifs are echoed and further developed in paintings, wall reliefs, and other works on informal display in this studio where Kevin Orth, the artist who made them, is playing his La Tosca Princess accordion. Standing against a brightly painted fabric backdrop covering most of the wall across the room from his *Bottle Shrine,* as he calls the above-described installation, Orth stares thoughtfully out an open window, sending his odd music into the junk-littered streets and glass-strewn parking lots of this industrial corridor on Chicago's North Side. **"This is the ugliest place in the world,"**

he says as his last improvised chord trails off into silence. **"This little area of the city is really filthy and violent, with all this traffic and noise and garbage. It takes a great deal of imagination and passion to get any beauty out of this landscape."**[1]

Orth manages to distill what beauty he can out of this harsh, grimy little corner of the Windy City by scavenging various cast-off materials from the blocks immediately surrounding the old warehouse where he works, then transforming them into fanciful, luridly colored creations such as the *Shrine* and other pieces that surround him in his studio. These comprise a growing body of work begun about five years ago. At thirty-two, Orth is still young enough to be considered a member of Generation X, and in fact he only began making art on a steady, daily basis in 1988, the same year he settled in Chicago. But his passionate interest in visual art dates back to his early childhood, and for most of his life he has been intensely involved in creative activities of one kind or another. His poetry and prose have appeared in a number of regional publications, and he once received an Ohio Arts Council writer's grant. During his teen years, he developed what he calls an **"obsessive"** fascination with music, and his spontaneous performance on the accordion makes it evident that he has continued to nourish this obsession.

In an increasingly specialized society such as ours, individuals with diverse enthusiasms and talents are too often dismissed as "dabblers." And in an art system that still maintains the outmoded categorical dichotomy of "mainstream" versus "outsider," there

seems to be little room for an artist with Orth's background. He's white, grew up in a middle-class family, has a university degree in English, and has had no formal art training. His exposure to the contemporary art world has taught him that these aspects of his history are strong impediments to his work being given serious attention, and for this reason he expresses some amazement that an institution like the Terra Museum would be interested in him. But despite the characteristics that set him apart from his better-known senior partners in this show, Orth learned what he knows about art and artmaking entirely on his own, just as they did, and he shares their commitment to working with found materials for both practical and metaphorical reasons. Perhaps more importantly, he shares with them a deep sense of moral and spiritual purpose in his artmaking and in the use of his related skills.

Summarizing his cultural origins, Orth betrays not a hint of nostalgia nor any desire to romanticize. **"I grew up in a drab midwestern industrial town, in a classic postwar nuclear family,"** he says. **"My father played the piano, and my mother painted, but art wasn't really central to our lives. It was just the kind of situation where you lived, you didn't make any trouble for anyone, not much happened, and that was that."** As an alternative to this mundane existence, Orth began exploring **"the parallel world of music and art that was completely different from the day-to-day world where I lived."**

Before moving to the above-maligned city of Akron when he was only two years old, Orth's family lived in Cleveland, where he was born in 1961, the second of two children. His earliest memories include shadowy recollections of his mother pushing him in a stroller through the Cleveland Museum of Art, which was near their apartment. The institution's permanent collection made a lasting impression on him during those visits and subsequent trips there in his youth. Among the images he recalls most vividly are **"an old-fashioned room like a grand hall in some medieval castle, where there were paintings by Goya and Velázquez, and life-size replicas of a Spanish conquistador**

and his horse wearing suits of armor." He also remembers **"gold boxes covered with jewels, lots of church objects—big crucifixes encrusted with gems—and huge collections of Asian art and modern art."** Orth entertained no notion of being an artist until he was in his mid-twenties, but even as a child he found the varied holdings of the Cleveland Museum **"fascinating in a very strange and personal way."**

His first activities with any connection to his current work were pursued in a small, concrete-walled room in his family's basement in Akron when he was eight or nine years old. **"I had a room in this unfinished cellar that was like a little cave,"** he remembers. **"I kept a hammer and nails and other things there, and I would go down and spend hours working with these little pieces of wood—gluing and combining them in different ways. Or I would drive hundreds of nails into a board, or pound metal into different shapes. Sometimes I'd pull the parts out of old clocks and make little things out of them. But the stuff I made down there was so weird and un-artlike that I didn't think of it as art, and neither did anyone else. It was more just an activity that I did. Of course, none of what I made in that house still exists. I had completely forgotten about all of this until a couple of years ago, when my father saw my studio and said, 'This looks like that little room you had in the basement when we lived on Kenilworth Drive.' Then all these memories came flooding back."**

Orth remembers a few more early visual-art experiments. **"When I was about thirteen or fourteen,"** he says, **"I found a deposit of clay in the ground in the woods near my house, and I dug out a big chunk of it and brought it home. I molded it into this very peculiar sculpture of a head, and I painted it. I kept it around for a long time, but eventually it just disappeared. I have no idea what happened to it."** A few years later, during his senior year in high school, he took a photography

class and became a camera-bug for a few years. **"I spent hours wandering around with my camera, and I'd just take pictures of everything—even the most ordinary things that no one else would have looked at. The photography teacher liked what I was doing, and he told me I ought to go to art school. That was just out of the blue, and I had no idea why he said it. No one had ever said that to me before, but of course I didn't go."**

Orth's present work and his comments about it indicate a concern with spiritual matters, and he acknowledges that this may be in part a reaction to the absence of any strong spiritual orientation in his early life. **"There was a nodding respect toward religion in my family, but that was as far as it went. About once a year we went to a Congregational church near our house. When I was growing up, my parents never said anything about sex and they never said anything about God—which was good, because it left me to form my own opinions. Beyond that, a very strong, Protestant work ethic was the best thing I learned."** Orth credits his parents for the undercurrent of humor that runs through his art. **"We were always cracking each other up around the house. I can remember family dinners with everyone just laughing until they cried and practically fell out of their chairs."**

He also cites the influence of Jewish humor, noting that for much of his childhood he lived in a predominantly Jewish neighborhood. **"Most of my friends were Jewish, so I was exposed to this culture that was much more exuberant and expressive than the German-American Protestant culture I come from. I was really struck by the smart-alecky quality of Jewish humor, and the irony, and a kind of tragic comedy. Looking back, I see that I learned a lot from that culture and was really heavily influenced by it."** Orth used some of these lessons in improvising routines he performed on occasion to entertain his friends:

"I would tell jokes, do contortions, make faces, do animal imitations—anything to get them laughing hysterically. I'd be jumping up in the air, spinning around and screaming, and just going bonkers. Later, when I read about shamans, I realized that when I had done that really crazy stuff for my friends, I was entering into the realm of ecstasy. There was something about those little performances that had that quality of joyous madness that you have in shamanism or in gospel singing, and I really loved it when I could enter that state. Of course, this also helped to make me a real discipline problem."

As a teenager, Orth began to explore other means of entering an ecstatic state. At the time, the most powerful of these for him was music. **"I became obsessed with music,"** he remembers. **"The public library in Akron had this great listening room with a $10,000 sound system, a soundproof room with huge speakers in the ceiling, and <u>no one</u> was using it except me. I would go in after school or on weekends and listen to classical music for hours, and I would have these incredible experiences. I remember listening to a recording of a Bach sonata on cello and piano one afternoon when I was sixteen, and I was so overwhelmed by the music that I felt like I was tripping, and I almost passed out. That's an experience that I've found myself having again and again listening to music ever since then."**

As much as he admired classical music, Orth wasn't immune to the pleasures of high-decibel, feedback-drenched rock, which could be considered an aural analogue to the loud, bold colors he now uses in his art. **"A tremendous influence,"** he admits, **"was listening to Jimi Hendrix play guitar through a set of headphones. It wasn't like I had electric colors pulsating through my brain or anything like that,"** he adds, **"but I was powerfully affected by that music. As far as I'm concerned, a great guitar solo by Jimi Hendrix is no different from Bach's**

'St. Matthew's Passion,' in the sense that with either one I get this feeling of having a curtain pulled back and suddenly getting a peek into other realities. It's a lot like the feeling I would get as a kid, doing these crazy, insane performances, and a lot like the feeling I sometimes get now when I'm making art. **Although with art it's a more level, sustained sense of joy,** and I can experience it for up to twelve hours at a time, instead of just in these intense bursts."

After entering Ohio State University in 1980, Orth continued to immerse himself in music. The listening room at the university library was a convenient substitute for the one he had frequented in his hometown, with the added benefit of a collection of musical scores. This resource allowed him to listen to Bach, Mahler, and some of his other favorite European classical composers while studying their orchestral scores and teaching himself how to read and write music after a fashion. Occasionally he would check out the scores and attempt to pick out the individual instrumental parts on a piano, an instrument that he had briefly studied during his childhood. **"This was a quiet, almost secret aspect of my life,"** he explains, **"but at the time I felt like it was my real life."**

It was at this point, early in his freshman year at Ohio State, that Orth began to take a serious interest in another non-visual art form. He had always enjoyed reading, and he had consistently done well in his high-school English classes, so he enrolled in a creative writing course. The class was taught by poet Gordon Grigsby, whom Orth remembers as **"an exciting, charismatic teacher. He had published a number of books and was a well-known writer in Ohio. I immediately got a good vibe off of him, and he became my first mentor. And as soon as I started writing, people told me I had a talent for it."**

Orth focused his literary efforts primarily on poetry, writing in a lyrical, imagist vein heavily influenced by Walt Whitman, William Carlos Williams, and James Wright, all of whom he began reading closely during his studies with Grigsby. **"A lot of my writing was very visual,"** he says. **"It had a lot of color and a lot of images and objects and situations, but it was never involved in any extended narratives. I was pretty good at writing these short, intense poems— these little bursts of imagery—but I was never much of a storyteller beyond just short anecdotes. And my poetry was <u>never</u> academic."** To his surprise, he says, **"That first year I started writing, I sent some poems off to university literary journals and— <u>pow!</u>—they were immediately accepted for publication. That was an incredible feeling, because up until then I had always figured I was just some kind of crazy troublemaker. So when I got my first publication contract in the mail, I felt like I was walking on air. I just couldn't believe that was me!"**

A simple but effective little anecdotal poem with the mock-grandiose title "A Treatise on Comedy" is fairly typical of Orth's early writing efforts. Based on a memory of boyhood mischief at a golf course in Akron, it's worth quoting in its entirety—not only for its strong visual qualities, but also for the insight it provides into the artist's sense of humor:

> The golfers would drive their balls
> over the long green curve of the hill.
> We would hide in the ravine and wait
> till we heard the fourth crack
> and whoosh, then run out and snatch
> all four while the last was still rolling.
> We dove into the brush and lay still
> as rabbits, imagining them stunned
> at the top of the hill, suddenly losing
> faith in their eyes, the turf, or the wind.
> We held our mouths when we heard them
> exclaiming, for we knew if we laughed
> the magic act would be over and they would chase
> us down into the marsh and beat us with their clubs.[2]

Buoyed by his quick success as a creative writer, Orth threw himself into his school work, and managed to graduate in three years. During his

last year at the university, he found part-time work at a neighborhood newspaper, where he gained experience as a reporter and copy editor. After receiving his bachelor's degree in 1983, he worked as a regular columnist for the same paper, contributing twice-weekly reviews of movies, music, dance, or new video releases. This provided him with sufficient income to pay his rent, while additional freelance writing and editing covered other expenses. He managed well enough that he was able to afford two brief low-budget trips to Europe in his first two years after graduation, spending time in France and England. A small writer's grant from the Ohio State Arts Council in 1985 encouraged him to keep working on his poetry in the midst of his efforts as a journalist and critic. But by early 1987, tiring of the constant deadline pressures and meager financial rewards of freelancing, he took a full-time job in a suburban public library. He continued to take on freelance assignments and to write poems in his spare time, and with his modest living expenses he was able to save $5,000 within less than a year.

On the surface, things seemed to be going well for Orth. He was making more money than ever before, and he had what he describes as **"an active social life with lots of friends."** But in retrospect, he says this was really a time of spiritual crisis in his life. **"I didn't know what it was yet,"** he recalls, **"but I knew there was something wrong. I had started drinking way too much, and I was beginning to realize I was not that great a writer. I was getting tired of cranking out columns for these little publications in this nowhere Ohio town and writing the occasional poem."**

At the same time, he was witnessing the protracted demise of a close older friend in Columbus, and was tormented by the possibility that he might one day wind up in the same desperate condition. **"I don't want to mention his name because of the way he died,"** Orth explains. **"But he was a failed composer who lived on a small trust fund, and he liked to drink. He was a brilliant guy who had at one time been a great piano player, but toward the end he couldn't even play a simple chord. During**

those months I was working at the library, I had to watch him dying a really grotesque death right before my eyes as a result of poisoning himself with alcohol for so long. He was in and out of the hospital, and he somehow managed to stay alive until after I moved to Chicago, but during that whole last year in Columbus I could just see his body shutting down. I was really traumatized by it and didn't know how to deal with it."

As a means of temporary escape from the site of his problems, if not the problems themselves, Orth took off for a ten-day vacation in Mexico in early 1988. His brief visits to Mexico City, Taxco, and Acapulco gave him a tantalizing glimpse of a rich culture that he saw as a kind of **"parallel universe."** He visited the local markets and saw a profusion of the brightly colored folk-art dolls and sculptures that, as he says, **"are almost mass produced, but they're great."** He was more impressed, though, with the religious art he encountered in the form of roadside shrines and devotional objects. He remembers a remarkable effigy in an Acapulco church and a scene he witnessed there which, while not uncommon in Mexico, nevertheless haunted him afterwards. **"There was this life-size sculpture of Jesus in a glass coffin. It was done in that horribly vivid Spanish realistic style —a Jesus all bloody and mangled after the crucifixion, with blood dripping down from his crown of thorns, but dressed in this beautiful white gown. There was a slot in the top of the coffin for worshipers to put money in, and there was money piled up all around this sculpture of Jesus. And while I was standing there, an old blind woman came up and knelt beside the coffin, and she was moaning and pawing at it like she was trying to touch Jesus through the glass, and she kept crying 'Help me, Jesus' over and over again. That's just one example of the kind of intense, almost surreal interaction I had with the people down there. There was something really electrifying about that trip that just zapped me awake."**

Two weeks after returning from Mexico, Orth witnessed a shocking event that was to have a profound impact on the future direction of his life. **"My apartment was next to a funeral home,"** he recounts, **"and on this particular day there were some people gathering there for a funeral. I was inside my apartment, and I heard this loud <u>whoomp</u> from the street. I thought maybe a car had run over a dog, so I went out to see, and there was this old lady lying face-down in a pool of blood in my front yard. She had been horribly injured by a hit-and-run driver. It turned out that this woman had been on her way to a funeral and had just gotten off the bus and was crossing the street when this car hit her, flung her up in the air, and deposited her on my lawn. And as I walked outside my building and saw her, she reached out to me and then just died right there in front of me."** This grimly visceral memento mori was a breaking point for Orth. **"I took it as a final, inevitable omen,"** says Orth, **"that it was time to get the hell out of there."**

During his years as a writer, Orth kept detailed journals, and the entries from the months leading up to the violent "omen" contain repeated references to escape and distant travels. Reviewing these documents recently for the first time since he wrote them, he was reminded, for example, of a dream in which he walked all the way from Columbus to San Francisco. He also remembered that at the time he had been reading a biography of Sherwood Anderson.[3] **"I identified with Anderson,"** he says, **"because he was an Ohio writer who had gone nuts. One day he just got up from his desk and started walking down a railroad track and kept going. The book quoted lots of strange little notes that he wrote on scraps of paper, and I copied those in my journal. I guess I felt like I was about to go nuts just like he had."**

Within a month after his encounter with the hit-and-run victim, Orth sold his belongings and used his savings to launch an aimless journey that would eventually take him as far from Ohio as he could get without leaving the planet. **"I felt like Henry Miller at the beginning of <u>Tropic of Cancer</u>,"** he recalls. **"I had no job, no prospects, and no real plan, and I felt happy for the first time in a really long while. My old teacher Gordon Grigsby was teaching in Malaysia, in Kuala Lumpur, and he had written to me and said, 'If you want to see Asia, come on over. I've got a huge house, and there's plenty of room.' So I decided I would go see him. First, though, I went to New Orleans, then I took the <u>City of New Orleans</u> train to Chicago and spent a few days visiting my sister. I got back on the train and went to San Francisco, and from there I flew to Singapore by way of Japan. From Singapore, I traveled up the Malay Peninsula to Thailand and stopped in Bangkok for a couple of days. That was the most fabulously strange, spiritual place I had ever seen. During this whole trip, I felt like I was tunneling down and getting closer and closer to this other life that was completely different from the one I knew. So I left Thailand and arrived in Kuala Lumpur, where Gordon had this big four-bedroom house full of beautiful rugs and handmade furniture and surrounded by tropical gardens."**

Malaysia's capital city impressed Orth almost as much as Bangkok had. Among the other qualities that made the place so distinctive, he was struck by **"the density of things there. There are people and signs stacked on top of each other everywhere you look, and more traffic than I'd ever seen anywhere. The trees and other vegetation are incredibly lush, with exotic plants growing out of the sides of the buildings, and the whole place is teeming with this mad proliferation of life. The colors seemed brighter than any I had ever seen, and I was amazed by the splendor and visual overload of the shrines that you see all over the place, especially the Chinese and**

Kevin Orth at Empress of Heaven Shrine, Kuala Lumpur, 1988 (photo: Wi Chang Ki)

Tamil shrines. They were like the visual equivalent of an electric-guitar amp cranked all the way up to ten. And the signs posted along the streets and on buildings and everywhere else in that city blew my mind. Each one was printed in four or more languages—Bahasa Malay, Tamil, English, and various Chinese dialects. I was fascinated by this beautiful script that was impossible for me to decode. These signs meant nothing to me as far as my being able to read them; to me they were just beautiful artwork."

During his first weeks in Kuala Lumpur, Orth began and nearly completed a long poem titled "Prayer for Deliverance from Self-Inflicted Wounds." This autobiographical meditation on impermanence, the final section of which he penned a few months later in Chicago, was essentially his literary farewell. He didn't realize it at the time, but as he explored Southeast Asia and enjoyed the hospitality of his mentor, he was about to leave writing behind in order to explore another aspect of his creative identity. The decisive moment came unexpectedly, in what seemed more a whim than a decision of serious consequence for his future. **"The weather was incredibly hot and humid in Kuala Lumpur,"** he remembers, **"and I wasn't feeling good. So I was walking around one morning, feeling hot and a little sick and bored, and I went into a stationery store. And I saw all these Chinese inks and fine brushes, and a bunch of different kinds of paper and pastel crayons, and all these great art materials. And when I noticed how cheap they were, I just suddenly thought, 'I'm going to get those.'**

"So I bought them and walked back to the house, went into the room where I was staying, cranked up the air conditioner and started painting and drawing. I stayed in there making art all that day and into the night, and when I got up the next morning I knew exactly what I was going to be doing. I went right back to making art, and I've pretty much kept up that pattern ever since. I was already in the habit of writing every day, so it wasn't hard to substitute painting and drawing. I know it seems odd, but what I did was more or less to drop writing one day and take up artmaking."

In fact, there was a direct relationship between writing and Orth's initial art experiments. The sketches and ink-brush paintings he produced that first day, holed up in his room at Grigsby's Southeast Asian villa, were inspired by the multilingual signs the fledgling artist had seen all over Kuala Lumpur. **"They were basically just this wild calligraphy I made up,"** he says. **"I wasn't copying the local signs, but I was making these abstract shapes and marks that were kind of loosely based on them."** It was as if he were attempting metaphorically to stretch language beyond its limits, to break through the barriers of logic and linguistic structure and create a new kind of language based on intuition and subconsciously directed free association. These initiatory explorations into visual territory can in that sense be seen as expressions of Orth's frustration with the inadequacy of words when it comes to conveying the essence of any intense feeling or experience.

Meat,

1989, cat. no. 197

It didn't take long for figural imagery to appear in his art. Soon after he began experimenting with the metalinguistic calligraphy just described, he commenced a series of drawings and paintings that centered around simply stylized, masklike faces— **"like a head with no ears on a stick,"** as he describes them. These quickly evolved into figures which **"looked like little monks wearing robes. I was turning out a tremendous number of variations on these little heads and figures, and these language drawings, turning the ideas over and over. And eventually these two things came together."** Indeed, the hubcap-mounted relief masks he has begun creating in the past two years echo the disembodied heads in these early pieces, just as his bottle figures can be seen as the latest incarnations of the monklike figures he first rendered on paper in 1988. And the mysteriously untranslatable calligraphy eventually evolved—or devolved—into the straightforward block letters spelling out lone words or brief phrases that appear in combination with the disembodied heads and solitary figures in some of his most recent works.

After about three months in Kuala Lumpur, Orth bought a cheap ticket on a Soviet Aeroflot jet that hopscotched frcm Singapore by way of New Delhi and Moscow to London. He had planned to spend some time there, in a vague, last-minute sort of way, but after soaking up the festive, colorful street life of Southeast Asia, he found England **"unbelievably depressing—a colorless, tasteless, expensive, sad, and worn-out place, basically a dead culture."** He quickly left Great Britain and hitchhiked through France to Spain. **"The French at least have a sense of beauty and an appreciation for great wine and food,"** he comments. **"And Spain was another one of those hot, strange cultures that I love, like Mexico or Thailand or Malaysia, so it was wonderful being there, but I was down to my last pennies, so I couldn't stay long. Then in August I flew back home, broke."**

"Clueless" about his future, as he puts it, Orth returned to Ohio for a reunion with old friends. **"A friend in Columbus was going to Chicago in a few weeks to start classes at the School of the Art Institute,"** he explains, **"and my sister lived in Chicago and had a vacant apartment in the bottom of the house where she lived with her husband and their little girl. So I picked up the few things I had left in Columbus, and I went to Chicago."** With his move to the Windy City, Orth began what he now sees as a time of **"rejuvenation"** in his life. It was a period of creative experimentation and intuitive self-reinvention, during which he immersed himself with increasing intensity in his newly begun artmaking activities and started to make something of a name for himself on the lively and often contentious Chicago art scene.

The original Barbara's Bookstore had been a counterculture institution in Chicago's Old Town, and it was there that Orth found employment soon after his arrival in the city. **"It was a hippie holdout from the sixties, in an old dilapidated building that has since been torn down,"** he remembers, **"and all the people who worked there were refugees from Reaganism. I heard Allen Ginsberg read there, and**

William Burroughs came in to sign books. So did Abbie Hoffmann." Orth stayed at his sister's house for a few weeks, then moved into a small basement apartment not far from the bookstore. **"That was my first real studio, and I immediately started filling it with art. I had become obsessed with making art, and I did it every day, but I had absolutely no sense of what I was doing. I wasn't thinking about it. I was just doing it. I was omnivorous. Anything I found, I followed. I had no agenda beyond experimentation and doing whatever occurred to me to do. I taught myself how to use colors. I made masks, little books, cast-plaster pieces, a lot of paintings, a whole series of boxes with painted surfaces and little objects inside them. All the basic threads of what I do now started there. At the time I kept everything and didn't throw anything away, and I accumulated tremendous amounts of stuff. By the time I'd been there a year, this tiny, dark garden apartment was crammed literally to the ceiling with things I'd made and things I'd found or saved. So about two years after coming to Chicago I moved into a bigger apartment where I had more room to work and display what I made."**

Reflecting back on this period and on the abrupt shift he made from writing to visual art, Orth says, **"Writing is a more intellectual process than painting, at least for me. And I'm not really an intellectual. If you want to describe a blue sky, there's no way to write the exact words to make a sky that's just the right shade of blue in someone else's mind. But with art, you just mix the colors until you've got the exact shade you want. That immediacy appealed to me."** Orth attempted to continue with his writing while devoting most of his creative attention to artmaking, but, he explains, **"I couldn't bring the kind of total systemic energy and concentration to writing that I have to in order to really do it, because I was so focused on art. It's like I had been working in the wrong form, because when I**

brought all of that energy to another form of expression, then—pow!—things really started happening." While visual art and writing seemed incompatible for him, Orth had no trouble staying actively involved with music even as he explored painting and other visual media. During his first year in Chicago, he bought an electronic keyboard and began recording his spontaneous compositions, sometimes playing them on compact tape machines concealed inside his mixed-media boxes.

Orth's first exhibition was an informal affair in a bar known as The Gallery, in the northwest part of the city. **"The place was in a scummy area, but somebody I'd met referred me to it and told me they showed art there, so I went over and talked to the bartender. I showed him some slides I'd had taken of my work and asked if he might be interested in showing some of it, and he said 'Sure.' So I brought some of my paintings and a few of the boxes I was making at the time over to this saloon, and some friends came to help me celebrate on the first night after I put them up. I got good responses to the work from a few of the musicians in the band that was playing that night, and there were other people in the bar who seemed to like it, but most of the people didn't seem to care about it. I remember one guy that night who was really wasted on heroin, and he was stumbling around looking like he was almost dead. That really depressed me, and it was the beginning of my concern that my work get shown in a proper way. I didn't like that show, but I was glad I did it for that reason."**

After moving to his second and larger Chicago apartment in the Lakeview district, Orth says, **"I started refining what I was doing a little more, but I was working really fast, spending more and more time in my studio, and picking up whatever I found, using it to make art. I started picking up boards and painting on them, and then I got interested in painting on surfaces that weren't flat. That's when I started painting on bottles I picked up in the streets. I had been doing a lot of walk-**

ing ever since I moved to Chicago, just around the neighborhoods where I lived. I lived in cheap apartments, but they were in wealthy sections of the city, and it was absolutely unbelievable what people in those neighborhoods would throw away. Sometimes the things I'd find and the way I'd find them almost seemed preordained. Like, one day I was feeling kind of down, and I left my apartment and started walking through this alley, and I immediately found this box that I opened up to find these little nineteenth-century German books the size of cigarette packs, illustrated with beautiful lithographs.

"There were lots of happy accidents like that. Another time, I needed a bottle-washing brush, and five minutes after mentioning that to someone, I walked out of my apartment to go to work, and there was a perfectly good bottle brush just lying there on the sidewalk." In addition to relatively unusual, fortuitously encountered objects like the brush and the miniature books, the budding artist began scavenging ordinary cast-offs such as burned-out light bulbs and the disposable glass bottles that eventually became materially central to his work. "I began to realize **you could make art** out of anything. After I'd made several of the bottle pieces, I started arranging them in groups. Then the groups started getting larger. I was slowly becoming more aware of what I was doing."

As with his show at The Gallery, Orth's second exhibition also came about through his own initiative, but this time he was more careful in selecting a forum for his work. He had read a newspaper article about local folk-art dealer Aron Packer, whom he contacted and managed to interest in his art. Packer presented a small selection of Orth's work at his in-home gallery in 1990, and he sold a group of the artist's painted bottle sculptures to a Lincoln Park restaurant for $1,000, a sum that Orth says startled him at the time. **"I didn't really believe I was an artist yet, and I didn't have much confidence in my work, so when I suddenly**

received a big check for something I made, that kind of blew my mind. I had never thought my art could sell like that. It really woke me up." That same year, the artist sought to promote his work through somewhat less conventional means, writing the producer of "Wild Chicago," a weekly program on WTTW-TV, the local Public Broadcasting station, and inviting them to his apartment. **"The host was a comedian who went around the city wearing khakis and a pith helmet looking for unusual people and things. The show was supposed to be an urban safari of the weird and wild. They'd had a number of other artists on. So they came to my apartment and filmed a segment there."**

Sometime between the filming of the "Wild Chicago" sequence and its airing in November 1990, Orth met another local artist who had already been a guest on that program and with whom he felt a strong and immediate affinity—none other than Gregory Warmack, a.k.a. Mr. Imagination. **"I had a little show in a coffee house around the corner from his apartment, which is in the same part of town where I was living then,"** Orth recalls. **"I had brought a few paintings and some bottles over. I was putting the show up, and I had several of the bottle sculptures lined up on the sidewalk under the el-train track. Mr. I happened to be walking by and saw them, and he stopped and introduced himself. We talked, and he invited me over, and of course I was completely amazed by his place and by his work. I felt like I had found a real kindred spirit. We traded work, and we've been friends ever since. His friendship and encouragement and his example have been very important to me. He's incredibly energetic and generous, and I've learned a tremendous amount just being around him and watching him work and relate to people."**

Meanwhile, Orth's own work continued to evolve as he slowly settled into his identity as an urban artist following his own intuitive path. For some time after

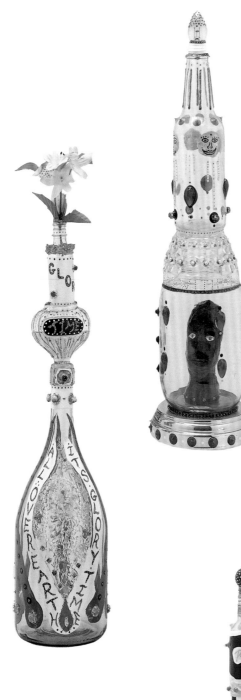

Details: Bottle Shrine from King Orthy's Cathedral of the Dreams, 1989-93, cat. no. 198

his "manic ramble / around the world," to quote from his final poem,[4] the artist's life remained **"crazy and turbulent."** He is quick to point out how this is reflected in his work from his first two or three years in Chicago. **"There's something kind of scary and spooky and slightly insane about a lot of the art I was making then. There were a lot of leering faces in the paintings I made when I first came here, and an eerie undercurrent of violence in some of that work. I think that's because I felt isolated at the beginning. It was almost like I was working in a vacuum, so I was doing it in a kind of crazy, defiant way. In my reading and my travels I had been exposed to a lot of spiritual and religious influences, but my sense of all of that was pretty raw and undigested, and at first I was just operating on this undirected and slightly psychotic energy."**

That began to change, the artist says, because of the artmaking process itself and the insights he began to have as a result of working with steady dedication for more than two years. **"As I spent more time working with my hands and with all these materials, making images every day for month after month, I began to realize that there's a kind of spiritual power in this activity, and I think it's a power that can get destructive and can run amok if it's not channeled properly. Not that the work I'd been doing up to that point was sinister or demonic or anything, but it just wasn't very focused at first."**

It was his growing awareness and acknowledgment of this spiritual dimension of artmaking, says Orth, that brought his work into sharper focus. He's not a member of any particular faith, nor does he subscribe to a traditional set of mythological beliefs about life, death, and the hereafter. But he confirms that he has grown **"more religious"** in the wake of this gradual realization about what he believes to be the source and the purpose of creative activity. **"I began to feel humbler about what I was doing and more respectful of the things I made, and to work more in a spirit of calm contemplation,"** he says, **"when I realized**

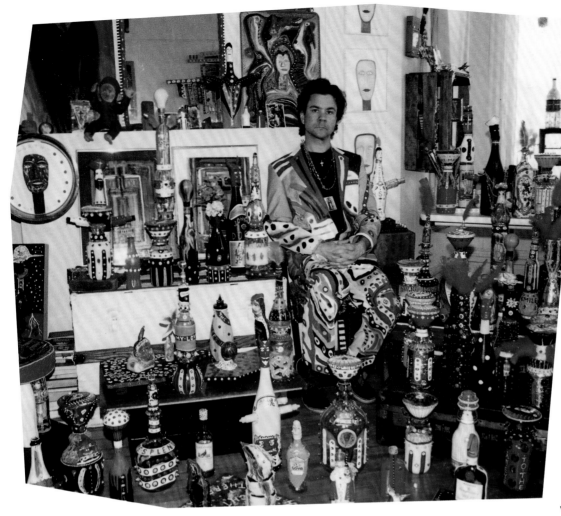

Kevin Orth in his studio, 1992 (photo: Kevin Orth)

"that I wanted my art to be in the service of God, ultimately, and to be a positive force. At that point, my work got much brighter, both figuratively and literally, and it became more lyrical and celebratory."

By late 1991, Orth's paintings, boxes, bottle sculptures, and other pieces had been featured in several more Chicago-area exhibitions, all in spaces much better appointed than the one in which he had made his debut nearly three years earlier, and with higher profiles than the private home where his second show had been held. It was at this point that he took what amounted to a bold step into the future. **"I had recently read the story in the Bible about Jesus walking on the water and his disciple Peter stepping out of the boat on nothing but faith, and I realized that was what I had to do—step out of the boat. I had to take a risk. So when I turned thirty I quit my job at the bookstore and decided I was**

going to <u>live,</u> that I wasn't going to do anything more just because someone else wanted me to. That was when I found this studio and rented it, even though I didn't have the money to afford it at the time. My work was selling, but not enough to justify my getting this space. Several friends told me I was crazy to do it, but I just had this faith that it would work out. Now, more than two years later, I'm still here and I'm in a museum show. Miracles do happen."

Among the other developments in his work since he acquired space in the old furniture warehouse has been an expansion of his interest in using ordinary found materials. While continuing to transform discarded glass objects into the cheerfully beatific, Buddha-like figures and hybridized charms that comprise his *Bottle Shrine,* he started collecting stray automobile hubcaps and using them as background haloes framing his cement relief masks. He began scavenging old wood-frame windows that had been removed from their original buildings, using these as surfaces for a number of recent paintings. But the *Shrine* remains his largest work, and in many ways it is the centerpiece of his entire artistic project. **"In the past few years,"** he explains, **"I've become fascinated with the idea of**

imaginary cities and imaginary structures, and the Bottle Shrine is part of that. I think of it as a maquette for a huge cathedral. This is obviously not a cathedral that's ever going to be built, but cathedrals have been an obsession of mine ever since I went to France and saw Chartres ten years ago. They're probably the ultimate artistic expression. I love the idea of a huge church structure filled with music and art, with light coming through the windows, and the idea of this being the visual and spiritual focal point for the community.

"So I wanted to create a cathedral of the imagination. And the name just suddenly came into my mind one day about four years ago, when I was getting really immersed in all this and my personality was starting to be strongly colored by the fact that I was spending so much time making art: King Orthy's Cathedral of the Dreams. It's partly a good-natured joke, playing on the idea that when you do something like this and establish a public presence as an artist, you're like a little king, but you're a king without a kingdom. But it's also meant to evoke something that I take more seriously—the idea of a parallel universe, an other world, an other life, Heaven, God, whatever you want to call it. It represents a divine state of being—my own personal church. So it's both a joke and a vision of paradise or nirvana. The Cathedral of the Dreams is where you wind up when you don't separate the divine from the profane, the spirit from the flesh, or the dream world from the waking world."

Six years ago, just before he gave up writing at age twenty-seven, Orth composed his last poem, whose title framed it as a prayer requesting "deliverance from self-inflicted wounds." As it turned out, he answered his own prayer, delivering and saving himself, healing his psychic wounds through the intuitively self-directed process of artmaking, recreating for the rest of us to see a world that previously existed only in his mind. Today he stands amidst the most recent evidence of that compulsive recreational

activity, fingering the plastic keys of his La Tosca Princess and gazing out the windows of his studio at the "real world" surrounding him on all sides. It's a world he knows well and continues to struggle in daily, like anyone else in this land of kingdomless kings. But for now, as for a number of hours nearly any other day, he enjoys taking refuge in the fantasy sanctuary he has contrived, making strange music and turning lowly trash into sparkling treasure in his *Cathedral of the Dreams.*

Notes

1. Unless otherwise indicated, all quotations from Kevin Orth are excerpted from interviews with the author on 24 July and 17 October 1993, or by telephone on 17, 19, 22, 26, 27, and 31 January, and 2 and 3 February 1994.

2. Kevin Orth, "A Treatise on Comedy," *Poetry East* [New York/Charlottesville: University of Virginia] 18 (Fall 1985): 37.

3. Kim Townsend, *Sherwood Anderson* (Boston: Houghton-Mifflin, 1987).

4. Kevin Orth, "Prayer for Deliverance from Self-Inflicted Wounds," unpublished manuscript, 1988.

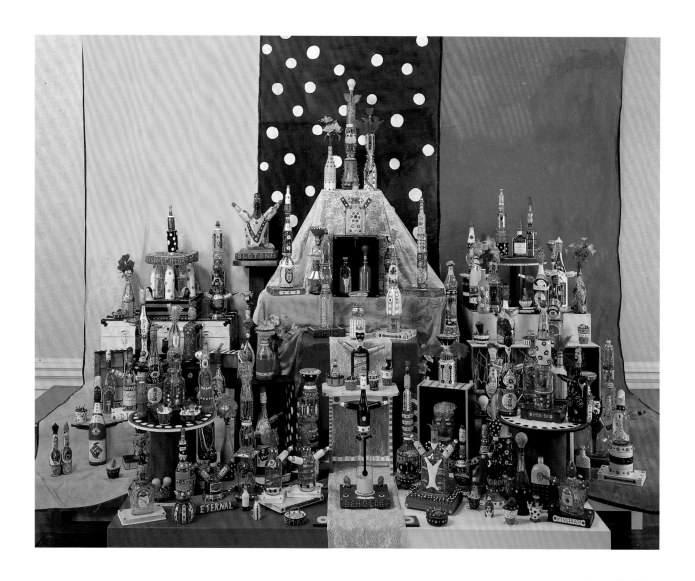

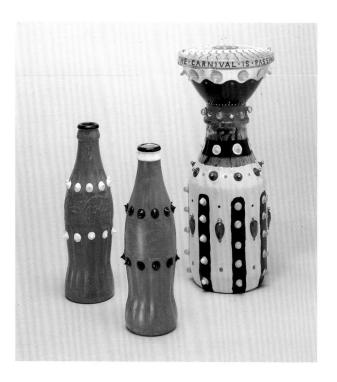

Bottle Shrine from King Orthy's Cathedral of the Dreams,
1989-93, cat. no. 198

Details: Bottle Shrine from King Orthy's Cathedral of the Dreams,
1989-93, cat. no. 198

**Details: Bottle Shrine
from King Orthy's
Cathedral of the
Dreams,**
1989-93, cat. no. 198

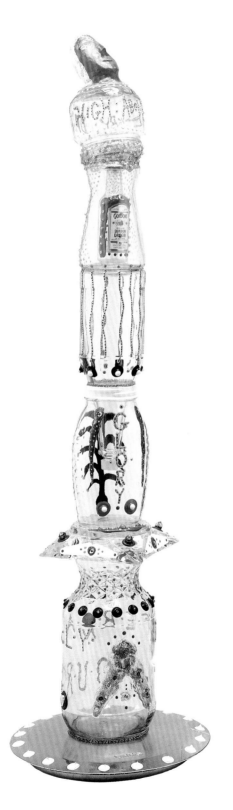

Details: Bottle Shrine from King Orthy's Cathedral of the Dreams,
1989-93, cat. no. 198
Including, on left,
Diamonda,
1992, cat. no. 232

The Magic Hour,
n.d., cat. no. 275

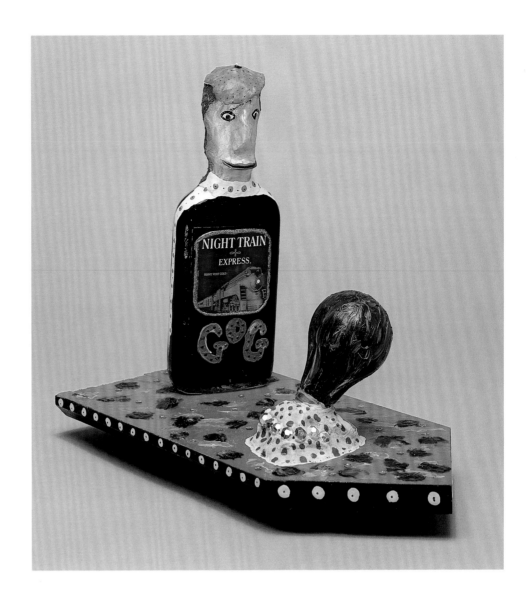

Gog & Magog,
1991, cat. no. 217

**I Had to Put on the
Shoes of the Gospel,**
1991, cat. no. 219

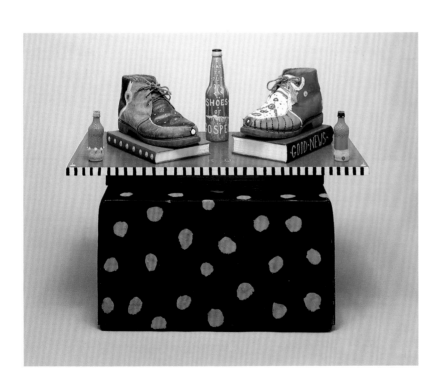

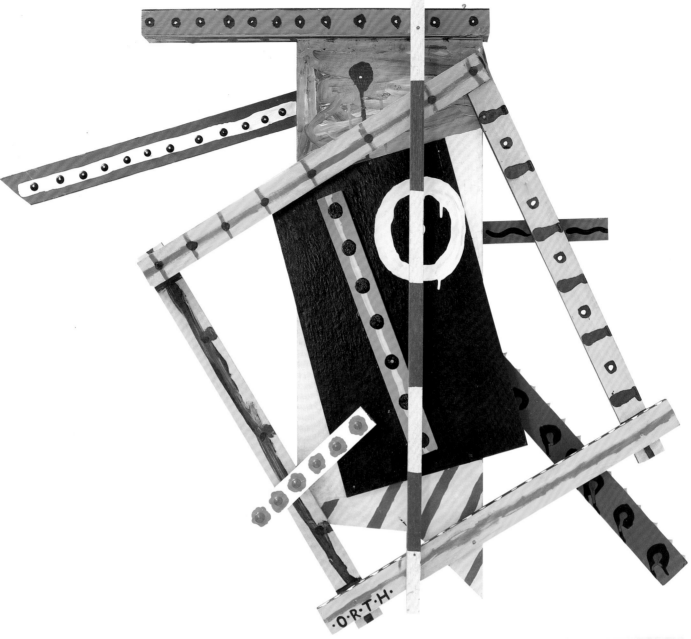

**Wood Assemblage
#2,**
1990, cat. no. 208

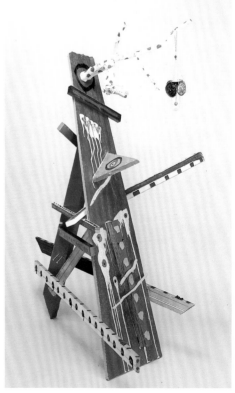

**Wood Assemblage
#4 with Beer-Can
Base Ornament,**
1990, cat. no. 210

**What the Man
Knows — What the
Man Thinks Of,**
1990, cat. no. 205

**The Master
Scavenger, King Orth,**
1992, cat. no. 240

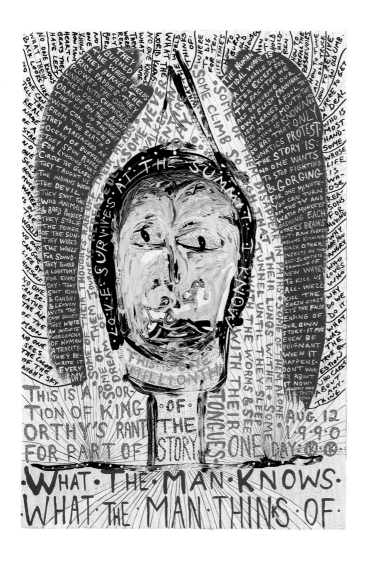

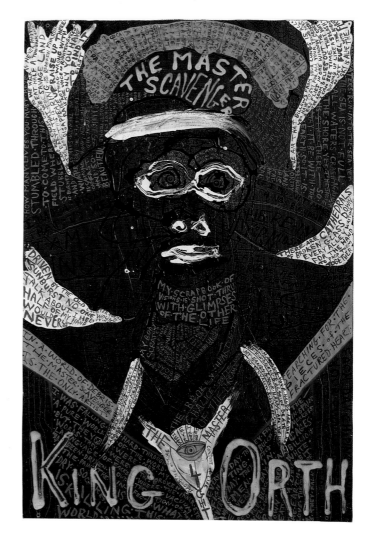

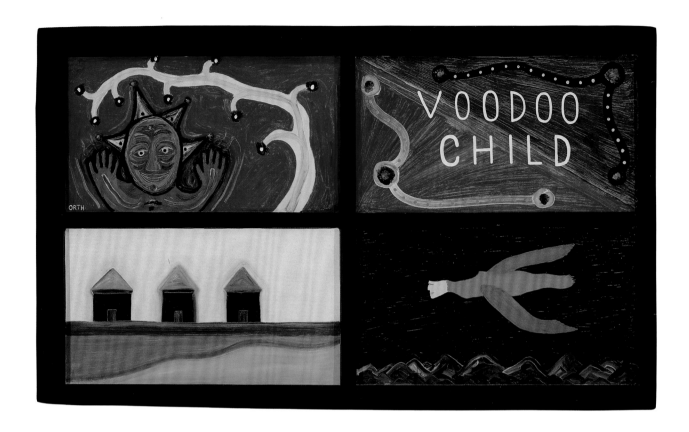

Voodoo Child,

1992, cat. no. 246

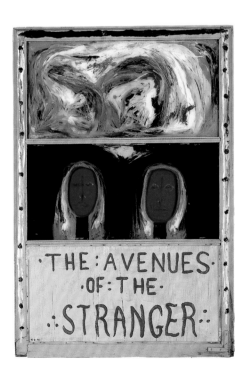

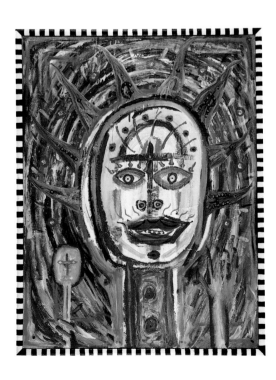

The Avenues of the Stranger,

1991, cat. no. 211

King Orth,

1991, cat. no. 220

**A Satisfied Soul
Loathes the Honey-
comb But to a
Hungry Soul Every
Bitter Thing Is Sweet,**
1990, cat. no. 203

Witness,
1990, cat. no. 206

Dreadnaught,
1992, cat. no. 233

Dreadnaught,
n.d., cat. no. 273

Self-Portrait,
n.d., cat. no. 277

Baroque Hubcap,
1991, cat. no. 213

Baby Basilisk,
1991, cat. no. 212

Hubcap Sculpture,
1992-93, cat. no. 250

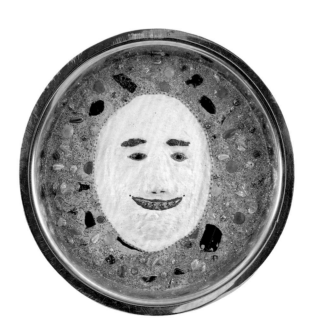

Glory Time,
1992, cat. no. 237

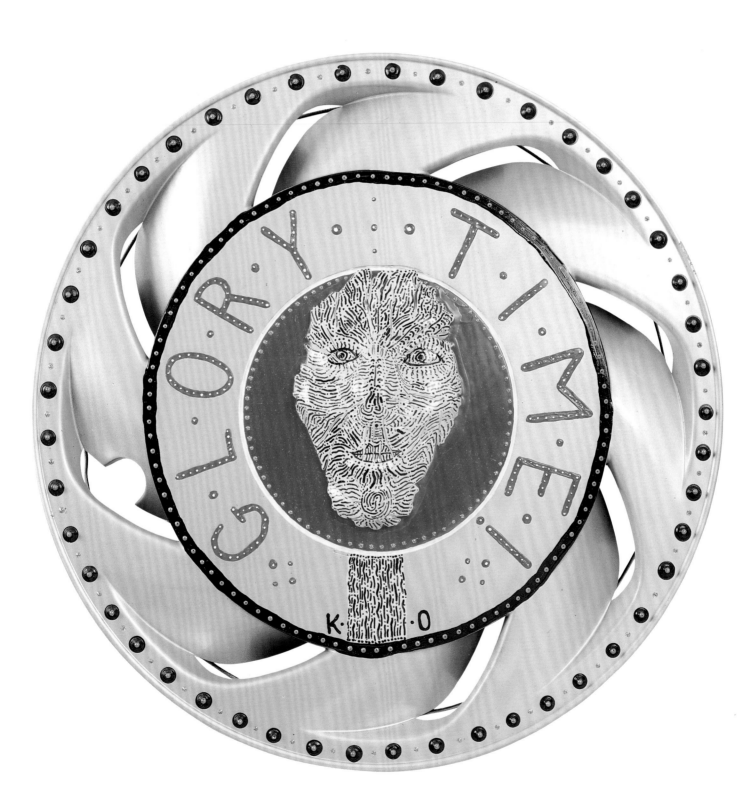

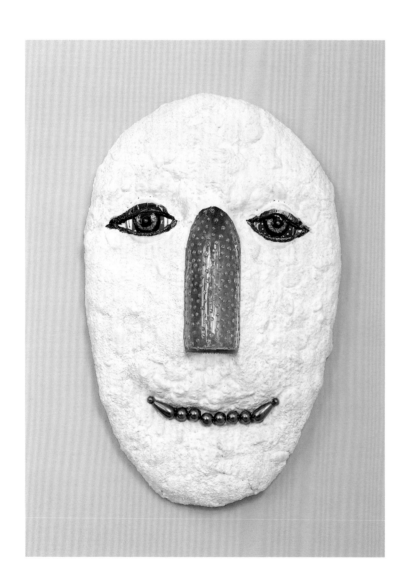

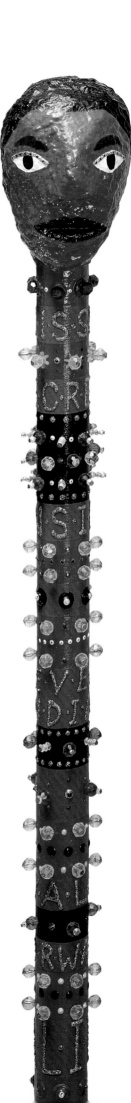

White Concrete Face,
1993, cat. no. 269

Blissful Secret Inside
Neverending Walk
Forward Alive Loving
Every Minute,
1993, cat. no. 252

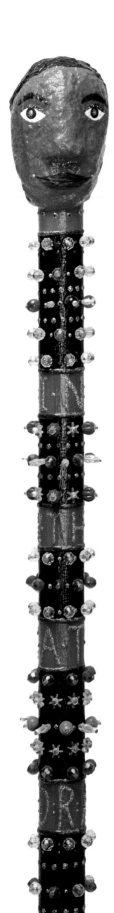

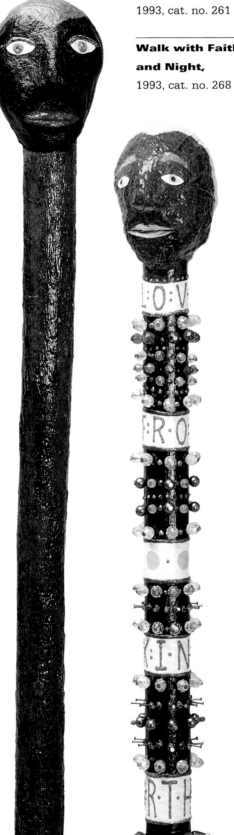

**King Orthy's
Cathedral of the
Dreams,**
1993, cat. no. 259

Voodoo Cane,
1993, cat. no. 267

**Love from King
Orthy's Cathedral of
the Dreams,**
1993, cat. no. 261

**Walk with Faith Day
and Night,**
1993, cat. no. 268

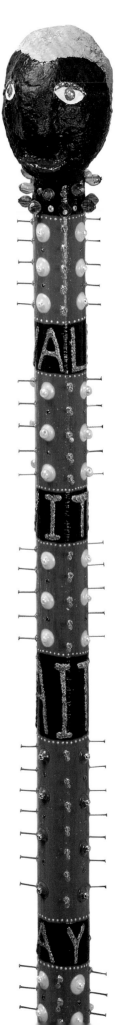

David Philpot

Born Chicago, 1940

Education
Illinois Technical College, Chicago, A.S., 1985

Selected Group Exhibitions

1993
Subjective Intentions, Rockford Art Museum, Illinois

1992
The Legacy of Africa in the New World, Waterloo Museum of Art, Iowa

Black Creativity, Museum of Science and Industry, Chicago

1991
Images in Black: Memory and Spirit in African-American Art, Carl Hammer Gallery, Chicago

Evidence of Spirit, University Museum, Southern Illinois University, Carbondale

Art: Chicago Style, Chicago Children's Museum, Chicago

African Heritage Festival, Field Museum of Natural History, Chicago

1990
The Chicago Show, Chicago Public Library Cultural Center (co-organized by the Art Institute of Chicago, City of Chicago Department of Cultural Affairs, and Museum of Contemporary Art, Chicago)

Contemporary Totems: Clan and Connections, Seventh Annual Festival of the Arts, Fourth Presbyterian Church, Chicago

1989
Black Art/Ancestral Legacy: The African Impulse in African-American Art, Dallas Museum of Art (traveled to High Museum of Art, Atlanta; Milwaukee Art Museum; Virginia Museum of Fine Arts, Richmond)

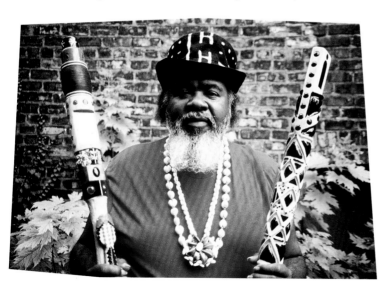

Emerging Art, Carl Hammer Gallery, Chicago

A Struggle for Freedom, An Achievement of Excellence, A. Montgomery Ward Gallery, Chicago Circle Center, University of Illinois at Chicago

1988
Outsider Art: The Black Experience, Carl Hammer Gallery, Chicago

1984
Four Black Folk Artists of Chicago, DuSable Museum of African-American History, Chicago

1981
Art and Fashion Show, Culture Center of Kankakee, Illinois

Annual Arts and Crafts Festival, DuSable Museum of African-American History, Chicago

Bibliography

"Artists Share Experience." *Chicago Defender,* 8 June 1991.

Conn, Sandra. "Absolut Big Break for These Two Chicago Artists." *Crain's Chicago Business,* 12 August 1991.

Daniels, Mary. "Gold Market, Black Art: Names to Know for Budding Collectors." *Chicago Tribune,* 3 February 1991.

"David Philpot Maker of Staffs." *Folk Art Finder* 13:2 (April-June 1992): 22-23.

Folk Art Society of America. Panel Discussion Review. *Folk Art Messenger* 5:1 (Fall 1991).

Jannot, Mark. "Outside In." *Chicago,* July 1992, 78ff.

Jarnuch, Ann. "Contributing Artists Pick Favorite in DMA's 'Ancestral Legacy.'" *Dallas Times Herald,* 15 December 1989.

Levenstone, Mildred. "Three Gentlemen of Chicago: A Trilogy of Folk Artists." *Newark Museum Newsletter,* November 1991.

Roselle, Robert V.; Alvia Wardlaw; and Maureen A. McKenna, eds. *Black Art/Ancestral Legacy: The African Impulse in African-American Art.* Dallas: Dallas Museum of Art, 1989.

Waterloo Museum of Art. *The Legacy of Africa in the New World.* Waterloo, Iowa: Waterloo Museum of Art, 1991.

Mr. Imagination

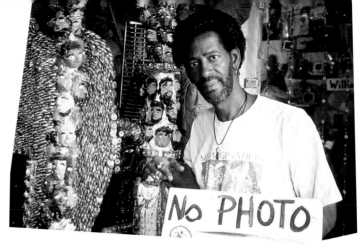

Born Chicago, 1948

Selected Individual Exhibitions

1993

The Eye Stands for Mr. Imagination, Carl Hammer
Gallery, Chicago

1992

FOCI: Mr. Imagination, Illinois State Museum,
Springfield (traveled to State of Illinois Art Gallery,
Chicago and Illinois State Museum Lockport Gallery)

Mr. Imagination, Sibell-Wolle Galleries, University
of Colorado at Boulder

Mr. Imagination, Plymouth State College, Plymouth,
New Hampshire

1991

The Eye Stands for Mr. Imagination, University of
Illinois at Chicago

1990

Mr. Imagination, Art Talk at Cairo, Chicago

Carl Hammer Gallery, Chicago

1986

The World of Mr. Imagination, Carl Hammer Gallery,
Chicago

1983

Mr. Imagination, Carl Hammer Gallery, Chicago

Selected Group Exhibitions

1993

Inside/Outside, Helander Gallery, New York

1991

*Spirited Visions: Portraits of Chicago Artists by Patty
Carroll,* State of Illinois Art Gallery, Chicago

Evidence of Spirit, University Museum, Southern Illinois
University, Carbondale

*Images in Black: Memory and Spirit in African-American
Art,* Carl Hammer Gallery, Chicago

Home Sweet Home, Columbia College, Chicago

The Cross: A Contemporary Image, Second Presbyterian
Church, Chicago

1989

*Black Art/Ancestral Legacy: The African Impulse in
African-American Art,* Dallas Museum of Art (traveled to
High Museum of Art, Atlanta; Milwaukee Art Museum;
Virginia Museum of Fine Arts, Richmond)

Sculpture: Inside and Out, Carl Hammer Gallery,
Chicago

1988

Portraits from Outside, Massachusetts College of Art,
Boston

Outsider Art: The Black Experience, Carl Hammer
Gallery, Chicago

1987

Mia Gallery, Seattle

Primitivo, San Francisco

1986

Mr. Imagination/Philadelphia Wireman/Boneman,
Oscarson Seigeltuch Gallery, New York

1985

Janet Fleischer Gallery, Philadelphia

1983

Artists of the Black Experience, Carl Hammer Gallery,
Chicago

Bibliography

Artner, Alan G. "Mr. Imagination: Artist Has Found
Celebrity through His Own Brand of 'Recycled' Images."
Chicago Tribune, 22 July 1993.

Calloway, Earl. "Mr. Imagination Pays Tribute to
Jacksons." *Chicago Defender,* 10 July 1984.

Carroll, Patty and James Yood. *Spirited Visions:
Portraits of Chicago Artists.* Urbana and Chicago:
University of Illinois Press, 1991.

"He Has a Dream." *Uptown News,* 6 November 1984.

Jannot, Mark. "Outside In." *Chicago,* July 1992.

Lyon, Christopher. "Stone Carvings by Mr. Imagination
Embody the Black Folk-Art Tradition."
Chicago Sun-Times, 22 May 1983.

Roselle, Robert V.; Alvia Wardlaw; and Maureen A.
McKenna, eds. *Black Art/Ancestral Legacy: The African
Impulse in African-American Art.* Dallas: Dallas Museum
of Art, 1989.

Sill, Robert. *FOCI: Mr. Imagination.* Springfield: Illinois
State Museum, 1992.

Taylor, Sue. "Sculptor Hammers Out His Identity."
Chicago Sun-Times, 6 February 1986.

Yood, James. "Mr. Imagination [at] Carl Hammer
Gallery." *Artforum* 28:8 (April 1990): 179-80.

Kevin Orth

Born Cleveland, 1961

Education
Ohio State University, Columbus, B.A., 1983

Selected Individual Exhibitions

1994
Idao Gallery, Chicago

Frank J. Miele Gallery, New York

1990
Aron Packer Gallery, Chicago

1989
The Gallery, Chicago

Selected Group Exhibitions

1994
Outsiders: A Survey of Self-Taught American Art of the Twentieth Century, Frank J. Miele Gallery, New York

1993
Leslie Howard Gallery, New York

1992
South Haven Center for the Arts, Michigan

Triangle Gallery, Chicago

The Angel Show, Second Presbyterian Church, Chicago

Raw Vision, Zerrien Gallery, Los Angeles

1991
World Tattoo Gallery, Chicago

Abstract Landscapes/Eccentric Bottle Sculptures, Fenway Gallery, Lakeside, Michigan

1800 Clybourn, Chicago

The Cross: A Contemporary Image, Second Presbyterian Church, Chicago

1990
Aron Packer Gallery, Chicago

Fenway Gallery, Lakeside, Michigan

Bibliography

Hershman, Ed. "Art Facts: Kevin Orth Paints All Kinds of Junk." *Chicago Reader,* 11 January 1991.

May, Michele. "Fenway Gallery Hosts 'King Orthy.'" *Harbor Country News,* 22 July 1993.

"Urban Art." *Folk Art Finder* 13:4 (January-March 1993).

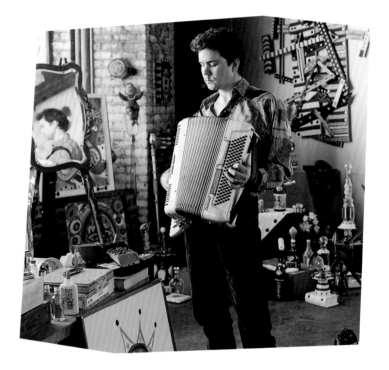

Dimensions are in inches followed by centimeters in parentheses; height (h.) precedes width (w.) precedes depth (d.). Other dimensions given may include length (l.) or diameter (diam.). All works are lent by the artist unless otherwise indicated.

David Philpot

1. **First Cane,** 1967-87
Ailanthus, leather,
upholstery tacks, paint
42 5/8 (108.3)

2. **Genesis,** 1971
Wood, wood putty,
leather, miniature
swords
56 1/2 (143.5)

3. **Name Stick,** 1972-92
Wood, leather, paint
66 1/2 (168.9)

4. **Edgar Philpot,** 1973
Ailanthus, leather,
metal chain, paint
72 3/8 (183.8)
Lent by Edgar Philpot,
Chicago

5. **Mixed-Up,** 1973-82
Ailanthus, leather, paint
68 3/4 (174.6)

6. **Janey,** 1974-87
Ailanthus, stain
57 3/4 (146.7)

7. **Flames,** 1974-93
Ailanthus, leather,
metal chain, paint
62 3/4 (159.4)

8. **Staff,** 1975-84
Ailanthus, stain,
copper tassel
65 1/4 (165.7)

9. **Scorpion/Alter
Ego/Love Stick,** 1977
Ailanthus, brass studs,
garnets, brass appliqué,
ricrac, cast metal lion
heads, scorpion plaques
72 (182.9)

10. **Staff,** 1980-92
Ailanthus, leather, paint
72 1/8 (183.2)

11. **Tower of Pisa,** 1981
Ailanthus, rope, bark,
wooden washers
78 1/2 (199.4)

12. **Mirrored Staff,** 1982
Ailanthus, mirrors,
leather, fabric, gold
piping, stain
68 3/8 (173.7)

13. **Mancuso,** 1983
Ailanthus
67 7/8 (172.4)

14. **Between Two
Worlds,** 1984
Ailanthus, garnets,
brass studs, leather
77 3/8 (196.5)

15. **Man and Wife,
My Better Half,** 1984
Ailanthus
59 (149.9)
Lent by the
City of Chicago Public
Art Collection

16. **Primal
Sophistication,** 1984
Ailanthus, wood putty
54 (137.2)
Lent by the
City of Chicago Public
Art Collection

17. **Castle,** 1986
Ailanthus, rope, garnets,
brass floral appliqué
72 1/2 (184.2)

18. **Foot Cane,** 1986
Wood, brass studs,
garnets, glass eyes
36 (91.4)

19. **Fire and Water,**
1986-93
Ailanthus
73 1/8 (185.7)

20. **Bubbles,** 1987
Ailanthus, stain
73 (185.4)

21. **Cane,** 1987
Ailanthus, leather,
wood putty, fiber
47 5/8 (121)
Lent by Dr. Margaret
Burroughs, Chicago

22. **Love, Peace and
Unity #2,** 1987
Ailanthus, stain
71 1/2 (181.6)

23. **Staff,** 1987
Ailanthus
75 1/4 (191.1)
Lent by AT&T

24. **Staff,** 1987
Ailanthus, hemp rope
72 3/8 (183.8)
Lent by the
DuSable Museum
of African-American
History, Chicago

25. **Cross-Cross,** 1988
Ailanthus
71 1/2 (181.6)
Lent by AT&T

26. **King Harold,** 1988
Ailanthus, garnets, brass
studs, brass tassels,
brass floral appliqué, cord
72 3/4 (184.8)

27. **Six Years,** 1988-93
Ailanthus, paint
72 5/8 (184.5)

28. **The Bannister
Snake,** 1989
Oak
72 1/8 (183.2)

29. **Hedge-Root Cane,**
1989
Wood, bark
34 3/4 (88.3)

30. **Serpent Staff,** 1989
Ailanthus, glass
eyes, paint
78 1/2 (199.4)

31. **Serpent Staff,** 1989
Ailanthus, stain
78 1/4 (198.8)

32. **Serpent with Apple,**
1989
Ailanthus, stain
83 (210.8)

33. **Snake Staff,** 1989
Ailanthus
60 (152.4)
Lent by AT&T

34. **Snake Staff,** 1989
Ailanthus
83 (210.8)
Lent by AT&T

35. **Struggle,** 1989
Ailanthus, garnets,
glass eyes, paint
78 1/8 (198.4)

36. **Essence of the
Universe #2,** 1989-92
Ailanthus, rope, stain
76 3/4 (195)

37. **Black and Red
Serpent,** 1990
Ailanthus, leather, brass
floral appliqué, mirrors,
garnets, brass studs,
plastic appliqué, paint
76 7/8 (199.1)

38. **Damballah,** 1990
Ailanthus, mirrors, glass
eyes, cowry shells, stain
73 3/8 (186.4)

39. **Love, Peace,
Unity and Space,
Launched,** 1990
Ailanthus, glass eyes,
copper tassels, stain
78 3/8 (199.1)

40. **Essence of the
Universe #1,** 1990-93
Ailanthus, cord, paint
76 1/8 (193.4)

41. **Essence of the
Universe #4
(The Eyes Have It),**
1990-93
Ailanthus, glass eyes,
stain
74 3/4 (189.9)

42. **Essence of the
Universe #7,** 1990-93
Ailanthus, rope, stain
75 1/2 (191.8)

43. **Essence of the
Universe #8,** 1990-93
Ailanthus, paint
76 1/4 (193.7)

44. **Essence of the
Universe #9,** 1990-93
Ailanthus, paint
77 7/8 (197.8)

45. **Launch Pad II,** 1990-93
Ailanthus, rope, paint
75 3/4 (192.4)

46. **Love, Peace and
Unity,** 1990-93
Ailanthus, brass chain,
paint, stain
74 3/4 (189.9)

47. **Puffin-Headed Cane,**
1990-93
Wood, glass eyes
35 1/4 (89.5)

48. **Damballah/Trinity,**
1991
Ailanthus, copper tassels,
glass eyes, mirrors, silver
studs, brass appliqué,
cowry shells, brass
tassels, metal chain,
paint, stain
74 1/2 (189.2)

49. **Serpent Staff,** 1991
Ailanthus, garnets, stain
75 (190.5)

50. **Staff,** 1991
Ailanthus, glass eyes,
copper tassels, brass
appliqué, brass studs,
paint, stain
73 7/8 (187.6)
Lent by Henry Suder
Elementary School,
Chicago

51. **Tribute to Malcolm X,**
1991
Ailanthus, garnets, paint
74 1/4 (188.6)

52. **Tribute to Malcolm X,**
1991
Ailanthus, paint
70 (177.8)
Lent by John and Laima
Hood, New York

53. **Tribute to Malcolm X
#2,** 1991
Ailanthus, paint
80 1/2 (204.5)

54. **Twisted Limb,** 1991
Wood, glass eyes, leather,
garnets, brass studs,
brass appliqué
59 7/8 (152.1)

55. **United Nations,** 1991
Ailanthus, brass studs,
glass eyes, garnets, metal
tassel, paint
64 7/8 (164.8)
Lent by James L. Tanner,
Janesville, Minnesota

56. **Essence of the
Universe #5,** 1991-92
Ailanthus, paint, stain
78 5/8 (199.7)

57. **Essence of the
Universe #10,** 1991-92
Ailanthus
76 1/4 (193.7)

58. **Essence of the
Universe #11,** 1991-92
Ailanthus, stain
75 7/8 (192.7)

59. **Diamond Staff,** 1992
Ailanthus, copper tassels,
garnets, brass appliqué,
paint
72 (182.9)

60. **Family Tree,** 1992
Ailanthus, copper chain,
paint
71 3/8 (181.3)

61. **Hearts,** 1992
Ailanthus, paint
68 1/4 (174.6)

62. See No Evil, Hear No Evil, Speak No Evil, 1992
Ailanthus, metal chain, cast metal monkeys
76 1/2 (194.3)

63. Staff, 1992
Ailanthus, brass studs, garnets, paint
59 5/8 (151.5)
Lent by Dr. Hazel B. Steward, Chicago

64. Staff, 1992
Ailanthus, garnets, copper tassles, brass appliqué, paint
65 7/8 (167.3)
Lent by Henry Suder Elementary School, Chicago

65. Staff, 1992
Ailanthus, mirrors, garnets
74 3/4 (189.9)
Lent by Henry Suder Elementary School, Chicago

66. Staff, 1992
Ailanthus, stain
71 3/8 (181.3)
Lent by Henry Suder Elementary School, Chicago

67. Three Different Shapes, 1992
Ailanthus, cord, paint
60 (152.4)

68. Tucan-Headed Cane, 1992
Wood, glass eyes
36 1/2 (92.7)

69. Three, Tri, Trinity, 1992-93
Ailanthus, glass eyes, copper tassles, brass appliqué, brass studs, paint
76 3/8 (194)

70. Bishop Arthur M. Brazier, Apostolic Church of God, 1993
Ailanthus, paint, stain
76 (193)

71. Brain I, 1993
Ailanthus
60 1/4 (153)

72. Brain II, 1993
Ailanthus, paint, stain
73 3/4 (187.3)

73. Cane, 1993
Wood
38 (96.5)

74. The Collage, 1993
Ailanthus
96 1/2 (245.1)

75. Cross-Cross Cane, 1993
Wood, bark
36 1/2 (92.7)

76. Dr. Hazel B. Steward, 1993
Ailanthus, paint
58 1/8 (148.6)
Lent by Dr. Hazel B. Steward, Chicago

77. Essence of the Universe #6, 1993
Ailanthus
78 (198.1)

78. Launch Pad I, 1993
Ailanthus, wood, metal chain, paint
77 (195.6)

79. Some Eyeballs, 1993
Ailanthus, glass eyes
78 (198.1)

80. Staff, 1993
Ailanthus, glass eyes, paint
71 7/8 (182.6)
Lent by Dr. Hazel B. Steward, Chicago

81. Waves, 1993
Ailanthus
75 1/4 (192.4)

Mr. Imagination

82. Dog, 1981
Foundry stone, paint
4 1/4 x 6 (10.8 x 15.2)

83. Female Figure, 1984
Foundry stone, glass marbles, brooch, paint, mixed media
12 x 8 1/4 (30.5 x 21)
Lent by Peter M. Howard, Chicago

84. Self-Portrait, 1984
Foundry stone, paint
16 (40.6)

85. African Princess, 1985
Foundry stone, shells, mixed media
16 7/8 (42.9)

86. Head with Oil-Can Spout, 1986
Foundry stone, paint, metal
23 3/8 x 7 x 6 3/4 (59.4 x 17.8 x 17.2)
Lent by the artist, courtesy Carl Hammer Gallery, Chicago

87. Head with Gemstones, 1987
Foundry stone, garnets
14 7/8 (37.8)

88. Large Head, 1988
Foundry stone
30 1/2 x 12 1/2 (77.5 x 31.8)
Lent by the artist, courtesy Carl Hammer Gallery, Chicago

89. Stone Relief, 1988
Foundry stone
19 1/2 x 25 1/2 x 4 1/4 (49.5 x 64.8 x 10.8)
Lent by the artist, courtesy Carl Hammer Gallery, Chicago

90. Dinosaur, ca. 1989
Foundry stone, paint
10 1/2 x 20 (26.7 x 50.8)

91. Untitled (Formal Attire), ca. 1989
Bottle caps, fabric
28 1/2 x 19 (72.4 x 48.3),
overall

92. Aquarium Shrine,
1989
Glass aquarium,
foundry stone, stones,
mixed media
12 1/4 x 24 3/8 x 12 5/8
(31.3 x 61.9 x 32.1)

93. Face with Hanger and Satin Bow, 1989
Plaster, mixed media
17 1/2 x 13 3/4
(44.5 x 34.9)

94. Large Head with Crown, 1989
Foundry stone
19 5/8 (49.9)

95. Mr. Imagination, A Common Nail, Uncommon Artworks, 1989
Plaster, mixed media
20 1/4 x 17 3/8
(51.4 x 44.1)
Private collection,
Chicago

96. Seated Prophet Figure with Columns,
1989
Foundry stone, paint
13 1/8 x 4 1/4
(33.3 x 10.8), column;
11 1/4 x 4 3/4
(29.9 x 12.1), figure;
13 3/8 x 3 3/4
(34 x 9.5), column

97. Bottle-Brush Head,
ca. 1990
Bottle brush, plaster,
paint, glitter
20 1/2 (52.1)
Lent by the artist,
courtesy Carl Hammer
Gallery, Chicago

98. Tar-Brush Heads,
ca. 1990
Tar brush, plaster,
paint, bottle caps, shells,
mixed media
12 1/2 x 11 1/4
(31.8 x 28.6)
Lent by Mr. and Mrs.
William McDowell,
Evanston, Illinois

99. Bottle-Cap Pedestal Table, 1990
Bottle caps, wood
25 3/4 x 16 1/4 x 17
(65.4 x 41.3 x 43.2)

100. Bottle-Cap Snake,
1990
Bottle caps, plaster,
wood, shells, paint
l. 84 3/4 (215.3)

101. Broom Head, 1990
Broom, plaster, nails,
mixed media
14 1/4 x 9 1/4
(36.2 x 23.5)
Lent by the artist,
courtesy Carl Hammer
Gallery, Chicago

102. Broom-Head Self-Portrait, 1990
Broom, plaster, paint,
mixed media
18 x 7 1/2 (45.7 x 19.1)
Lent by the artist,
courtesy Carl Hammer
Gallery, Chicago

103. Cadillac Broom Head, 1990
Broom, plaster, paint,
mixed media
17 3/8 x 8 1/4 (44.1 x 21)
Lent by the artist,
courtesy Carl Hammer
Gallery, Chicago

104. Diamond-Shaped Bottle-Cap End Table, 1990
Bottle caps, wood
26 1/4 x 12 1/2 x 25 1/2
(66.7 x 31.8 x 64.8)

105. Female Face with Bottle-Cap Headdress, 1990
Bottle caps, plaster,
clay, faux pearls,
imitation teardrop
crystal, mixed media
44 1/4 (112.4)

106. Female Head with Shell-and-Bead Earrings, 1990
Foundry stone, broom,
shells, wooden beads
19 1/4 (48.9)

107. "GB" Tennis Shoe,
1990
Sneaker, plaster,
mixed media
6 5/8 x 12 7/8
(16.8 x 32.7)

108. Head, 1990
Foundry stone, broom,
cowry shells, mixed
media
21 (53.3)
Lent by the artist,
courtesy Carl Hammer
Gallery, Chicago

109. Log Head, 1990
Log, plaster, bottle caps,
mixed media
20 1/2 (52.1)
Lent by the artist,
courtesy Carl Hammer
Gallery, Chicago

110. Log Woman, 1990
Log, bottle caps,
mixed media
23 7/8 (60.6)

111. Male Face with Hubcap and Stove Pipe, 1990
Bottle caps, stove pipe,
hubcap, copper pipe,
mixed media
50 1/2 (128.3)

112. Male with Beard,
1990
Plaster, bottle caps,
hemp, mixed media
51 (129.5)

113. Miniature Throne,
1990
Paintbrushes, wood,
bottle caps, metal,
mixed media
19 3/8 x 8 1/4 x 6 1/2
(49.2 x 21 x 16.5)
Lent by Mr. and Mrs.
William McDowell,
Evanston, Illinois

114. Native American Head, 1990
Foundry stone
24 x 21 3/4 (61 x 55.3)

115. Scrub-Brush Head,
1990
Scrub brush, bottle caps
plaster, paint, mixed
media
10 1/4 (26)
Lent by the artist,
courtesy Carl Hammer
Gallery, Chicago

116. Staff, 1990
Bottle caps, wood,
plaster, mixed media
42 3/4 (108.6)
Lent by the artist,
courtesy Carl Hammer
Gallery, Chicago

117. Staff with Snake and Heads, 1990
Bottle caps, plaster,
wood, mixed media
51 1/2 (130.8)
Lent by the artist,
courtesy Carl Hammer
Gallery, Chicago

118. Walking Stick with Bottle-Cap Hat and Necklace, 1990
Bottle caps, plaster,
wood, mixed media
41 (104.1)
Lent by Kevin Orth,
Chicago

119. Bottle-Cap Fish, 1991
Bottle caps, wood,
tin, paint
l. 28 3/8 (73)

120. Broom Head, 1991
Broom, plaster, paint,
mixed media
13 x 7 1/2 (33 x 19.1)
Lent by the artist,
courtesy Carl Hammer
Gallery, Chicago

**121. Broom Head with
Cigarette Butts,** 1991
Broom, plaster,
mixed media
14 x 7 5/8 (35.6 x 19.4)
Lent by the artist,
courtesy Carl Hammer
Gallery, Chicago

**122. Broomstick with
Paintbrushes,** 1991
Broomstick, paint-
brushes, china shard,
bottle cap, hair roller,
nails, mixed media
41 5/8 (105.7)
Lent by Orren Davis
Jordan and Robert
Parker, Chicago

**123. Female Bottle-Cap
Figure,** 1991
Bottle caps, broom,
plaster, wood,
mixed media
46 1/2 (118.1)
Lent by the artist,
courtesy Carl Hammer
Gallery, Chicago

124. Future Painting, 1991
Wood, mixed media
19 3/4 x 37 3/4
(50.2 x 95.9)

125. "Keep This Coupon,"
1991
Plaster, mixed media
16 3/8 x 13 1/2
(41.6 x 34.3)

126. King, 1991
Bottle caps, broom,
plaster, mixed media
29 (73.7)

127. Log Head, 1991
Log, paintbrush,
bottle caps, plaster,
mixed media
21 1/2 (54.6)
Lent by the artist,
courtesy Carl Hammer
Gallery, Chicago

**128. Male Face with
Copper Cylinder,**
1991
Bottle caps, plaster
copper cylinder,
mixed media
33 1/8 (84.1)
Lent by the artist,
courtesy Carl Hammer
Gallery, Chicago

129. Male Figure, 1991
Bottle caps, nails,
rhinestones, plaster,
mixed media
18 (45.7)

**130. Male Head with
Shells,** 1991
Foundry stone, broom,
sea shells
23 1/2 (59.7)
Lent by the artist,
courtesy Carl Hammer
Gallery, Chicago

131. Mr. I, 1991
Tin, bottle caps, plaster,
mixed media
16 (40.6)

**132. Paintbrush with
Japanese Bottle
Cap,** 1991
Paintbrush, plaster,
bottle cap, paint,
mixed media
9 3/8 (23.9)
Lent by the artist,
courtesy Carl Hammer
Gallery, Chicago

133. Roller-Brush Head,
1991
Paint roller, bottle caps,
nails, plaster, paint
10 3/4 (27.3)
Lent by the artist,
courtesy Carl Hammer
Gallery, Chicago

134. Rose, 1991
Steel wool, tin,
bottle caps, plaster,
mixed media
17 1/4 (43.8)

135. Scrub-Brush Head,
1991
Scrub brush, plaster,
paint
21 1/8 (53.7)
Lent by the artist,
courtesy Carl Hammer
Gallery, Chicago

136. Self-Portrait Staff,
1991
Bottle caps, plaster,
wood, paint
66 7/8 (169.9)
Lent by the artist,
courtesy Carl Hammer
Gallery, Chicago

**137. Small Bottle-Cap
Fish,** 1991
Bottle caps, tin, wood,
buttons, paint
l. 22 3/8 (56.8)
Lent by the artist,
courtesy Carl Hammer
Gallery, Chicago

138. Small Male Figure,
1991
Bottle caps, plaster,
mixed media
17 1/4 (43.8)
Lent by the artist,
courtesy Carl Hammer
Gallery, Chicago

139. Small Male Figure,
1991
Bottle caps, tin,
steel wool, mixed media
13 1/2 (34.3)
Lent by the artist,
courtesy Carl Hammer
Gallery, Chicago

**140. Stamp, Red Bird,
and Washers,** 1991
Plaster, metal washers,
nails, mirror, wire,
mixed media
40 1/2 x 17 3/4
(102.9 x 45.1)

**141. Whisk-Broom Head
Self-Portrait,** 1991
Broom, plaster, mixed
media
11 3/4 x 6 3/4 (29.9 x 17.2)
Lent by the artist,
courtesy Carl Hammer
Gallery, Chicago

142. Black Snake Staff,
ca. 1992
Bottle caps, plaster,
buttons, wood,
mixed media
40 3/4 (103.5)
Lent by the artist,
courtesy Carl Hammer
Gallery, Chicago

143. Boxer, 1992
Paintbrush, plaster, paint
11 5/8 x 9 1/2 (29.5 x 24.1)

144. Broom Head, 1992
Broom, buttons,
plaster, paint
13 3/8 x 7 1/4 (34 x 18.4)
Lent by the artist,
courtesy Carl Hammer
Gallery, Chicago

145. Broom Head, 1992
Broom, plaster, paint,
mixed media
11 1/4 x 7 (28.6 x 17.8)
Lent by the artist,
courtesy Carl Hammer
Gallery, Chicago

146. Broom Head, 1992
Broom, plaster, rope, paint
13 1/2 x 11 1/2
(34.3 x 29.2)
Lent by the artist,
courtesy Carl Hammer
Gallery, Chicago

**147. Broom-Head
Self-Portrait,** 1992
Broom, plaster, paint,
mixed media
13 x 6 1/4 (33 x 15.9)
Lent by the artist,
courtesy Carl Hammer
Gallery, Chicago

148. Button Tree, 1992
Tree, buttons, bottle caps,
mixed media
54 1/2 (138)

149. Child's Throne and Footstool, 1992
Bottle caps, wood putty, buttons, velvet, copper pipe fittings, wood, mixed media
54 x 30 1/2 x 12 (137.2 x 77.5 x 30.5), throne; 8 1/2 x 11 3/4 x 10 3/8 (21.6 x 29.9 x 26.4), footstool
Lent by Orren Davis Jordan and Robert Parker, Chicago

150. Double-Faced Self-Portrait, 1992
Plaster, bottle caps, mixed media
17 1/8 (43.5)

151. Faces from the Past, 1992
Tree branch, wood putty, bottle caps, wire, gold foil, mixed media
109 (276.9)

152. Hand-Brush Head, 1992
Hand brush, bottle caps, buttons, plaster, paint
13 3/4 (34.9)
Lent by the artist, courtesy Carl Hammer Gallery, Chicago

153. Male Bottle-Cap Figure with Cobra Head, 1992
Bottle caps, steel can, plaster, mixed media
30 3/4 (78.1)
Lent by the artist, courtesy Carl Hammer Gallery, Chicago

154. Male Bottle-Cap Figure with Paintbrush and Necklace, 1992
Bottle caps, paintbrush, broom, wood, mixed media
52 1/4 (132.7)
Lent by the artist, courtesy Carl Hammer Gallery, Chicago

155. Male Bottle-Cap Staff, 1992
Bottle caps, plaster, wood, mixed media
46 1/2 (118.1)
Lent by the artist, courtesy Carl Hammer Gallery, Chicago

156. Memory Jug with Buttons, 1992
Champagne bottle, plaster, buttons
11 3/4 (29.9)

157. Paintbrush, 1992
Paintbrush, plaster, compact-disk shard, mixed media
10 3/8 (26.4)
Lent by the artist, courtesy Carl Hammer Gallery, Chicago

158. Paintbrush, 1992
Paintbrush, plaster, compact-disk shard, paint
9 3/8 (23.9)
Lent by the artist, courtesy Carl Hammer Gallery, Chicago

159. Paintbrush, 1992
Paintbrush, plaster, paint, mixed media
12 1/8 (30.8)
Lent by the artist, courtesy Carl Hammer Gallery, Chicago

160. Paintbrush, 1992
Paintbrush, plaster, paint, mixed media
12 1/4 (31.1)
Lent by the artist, courtesy Carl Hammer Gallery, Chicago

161. Push-Broom Head, 1992
Push broom, bottle caps, plaster, paint
26 3/8 (67)
Lent by the artist, courtesy Carl Hammer Gallery, Chicago

162. Scrub-Brush Self-Portrait, 1992
Bottle caps, buttons, plaster, mixed media
22 1/2 (57.2)
Lent by the artist, courtesy Carl Hammer Gallery, Chicago

163. Self-Portrait Shovel-Handle Staff with Buttons, 1992
Wood, plaster, buttons, metal, paint, mixed media
39 1/8 (99.4)
Lent by Herbert Waide Hemphill, Jr., New York

164. Small Bottle-Cap Fish, 1992
Bottle caps, tin, wood, paint
l. 13 3/4 (34.6)

165. Small Bottle-Cap Fish, 1992
Bottle caps, wood, tin, paint
l. 24 (61)

166. Snake Woman, 1992
Bottle caps, plaster, wood, mixed media
47 7/8 (121.6)

167. Throne and Footstool, 1992
Bottle caps, velvet, buttons, mixed media
81 x 42 x 23 1/2 (205.7 x 106.7 x 57.2), throne; 9 1/2 x 18 3/8 x 11 3/4 (24.1 x 46.7 x 29.9), footstool

168. Angel Paintbrush, 1993
Paintbrush, plaster, paint
10 3/4 (27.3)
Lent by the artist, courtesy Carl Hammer Gallery, Chicago

169. Bass Instrument, 1993
Wood, bottle caps, plaster, copper, mixed media
Reproduced on cover of Larry Gray's compact disk "Solo + Quartet"
52 3/8 x 11 1/2 (133 x 29.2)

170. Black Cobra Staff, 1993
Bottle caps, plaster, buttons, wood, mixed media
52 (132.1)
Lent by the artist, courtesy Carl Hammer Gallery, Chicago

171. Blue Cobra Staff, 1993
Bottle caps, plaster, wood, mixed media
l. 38 3/8 (97.5)
Lent by the artist, courtesy Carl Hammer Gallery, Chicag

172. Bottle-Cap Fish, 1993
Bottle caps, tin, wood, paint
l. 41 (104.1)

173. Bottle-Cap Frame, 1993
Bottle caps, wood, nails
71 1/2 x 52 1/4 (181.6 x 132.7)

174. Bottle-Cap Shadow Box with Self-Portrait Paintbrush, 1993
Bottle caps, paintbrush, plaster, mixed media
15 7/8 x 14 1/8 (40.3 x 35.9)

175. Bottle-Cap Shadow Box with Small Paintbrush Head, 1993
Bottle caps, paintbrush, plaster, mixed media
16 1/4 x 14 3/8 (41.3 x 36.5)

176. Bottle-Cap Shadow Box with Small Paintbrush Head, 1993
Bottle caps, paintbrush, plaster, mixed media
18 1/4 x 11 1/2 (46.4 x 29.2)

177. Bottle-Cap Shadow Box with Small Paintbrush Head, 1993
Bottle caps, paintbrush, plaster, mixed media
18 3/4 x 13 7/8 (47.6 x 34)
Lent by Jerry Smith, Chicago

178. Eight-Headed Totem, 1993
Bottle caps, mirror, nails, buttons, flip tops, corks, keys, doorknob, aluminum cans, dried palm, paintbrushes, paint, mixed media
102 (259.1)
Lent by the artist, courtesy Carl Hammer Gallery, Chicago

179. Female Bottle-Cap Figure, 1993
Bottle caps, plaster, garnet, mixed media
24 1/2 (62.2)

180. Five-Headed Totem, 1993
Bottle caps, plaster, corks, mixed media
52 (132.1)
Lent by the artist, courtesy Carl Hammer Gallery, Chicago

181. Junior, 1993
Bottle caps, broom, plaster, mixed media
41 1/4 (104.8)

182. Male Bottle-Cap Figure, 1993
Bottle caps, plaster, mixed media
20 1/2 (52.1)
Lent by the artist, courtesy Carl Hammer Gallery, Chicago

183. Male Bottle-Cap Figure with Self-Portrait Staff, 1993
Bottle caps, nails, plaster, garnet, rhinestones, mixed media
27 1/4 (69.2)

184. Male Bottle-Cap Figure with Staff, 1993
Bottle caps, brush, plaster, buttons, mixed media
36 (91.4)
Lent by Peter M. Howard, Chicago

185. Memory Jug, 1993
Glass jug, plaster, buttons
12 1/8 (30.8)

186. Memory Jug with China, 1993
Champagne bottle, plaster, china shards
15 (38.1)

187. Memory Jug with Toys, 1993
Glass jug, plaster, mixed media
11 1/2 (29.2)

188. Paintbrush Figure, 1993
Paintbrush, plaster, bottle caps, mixed media
12 3/8 x 8 1/2 (31.4 x 21.6)

189. Royal Scepter Self-Portrait, 1993
Bottle caps, plaster, wood, mixed media
49 1/2 (125.7)

190. Self-Portrait Cane, 1993
Bottle caps, buttons, plaster, wood, mixed media
37 3/4 (95.9)

191. Six-Headed Totem, 1993
Plaster, broom, bottle caps, buttons, velvet, glass, mixed media
58 (147.3)
Lent by Peter M. Howard, Chicago

192. Small Figure with Hat, 1993
Bottle caps, plaster, mixed media
19 1/4 (48.9)
Lent by the artist, courtesy Carl Hammer Gallery, Chicago

193. Standing Prophet Figure with Stone Wall, 1993
Foundry stone, marble base
12 1/2 x 20 1/8 (31.8 x 51.1), with base

194. Twins, 1993
Paintbrush, bottle caps, plaster, mixed media
10 3/4 x 8 1/2 (27.3 x 21.6)

195. Bottle-Cap Fish, n.d.
Bottle caps, wood, tin, paint
10 1/2 x 27 (26.7 x 68.6)
Lent by AT&T

Kevin Orth

196. Mask, 1989
Oil, glass, marbles on handmade paper
11 1/2 (29.2)

197. Meat, 1989
Oil, enamel on cardboard, found frame
27 x 23 1/8 (68.6 x 58.7)

198. Bottle Shrine from King Orthy's Cathedral of the Dreams, 1989-93
Boxes, table, cable spools, crates, trunk, saw horses, bottles, suitcase, mirror, folding screen, lace curtains, blanket, mixed media
128 x 176 x 80
(325.1 x 447 x 203.2), overall (variable)

199. Abstract Hanging Window, 1990
Oil on window
31 3/4 x 16 (80.7 x 40.6)

200. Face This Face, 1990
Acrylic, oil, enamel on plywood, wood pallet
28 5/8 x 28 1/8
(72.7 x 71.4)

201. Hubcap Sculpture, 1990
Hubcap, plaster, beads, artificial flowers, paint
diam. 14 1/2 (36.8)

202. King Orth Stick Man, 1990
Wood putty, enamel, acrylic, felt-tip marker, nails on wood
35 x 5 1/2 (88.9 x 14)

203. A Satisfied Soul Loathes the Honeycomb But to a Hungry Soul Every Bitter Thing Is Sweet, 1990
Acrylic, oil, catalytic converter, beads on found framed painting
21 1/8 x 21 1/8
(53.7 x 53.7)

204. The Two Brothers, 1990
Acrylic on drawer piece
10 1/2 x 18 1/2 (26.7 x 47)

205. What the Man Knows—What the Man Thinks Of, 1990
Oil on masonite
24 5/8 x 16 1/2
(62.6 x 41.9)
Lent by Herbert Waide Hemphill, Jr., New York

206. Witness, 1990
Oil, enamel on plywood
32 1/2 x 25 1/2
(82.6 x 64.8), overall

207. Wood Assemblage #1, 1990
Glass, beads, nails, cork, acrylic, enamel, oil on wood
28 1/4 x 47 1/2
(71.8 x 120.7)

208. Wood Assemblage #2, 1990
Beads, acrylic, enamel, oil on wood
44 x 41 (111.8 x 104.1)

209. Wood Assemblage #3, 1990
Nails, acrylic, enamel, oil on wood
69 7/8 x 33 3/4
(177.5 x 85.7)

210. Wood Assemblage #4 with Beer-Can Base Ornament, 1990
Nails, acrylic, enamel, oil on wood
54 x 21 x 45 1/8
(137.2 x 53.3 x 114.6), overall

211. The Avenues of the Stranger, 1991
Oil, acrylic on window
40 x 27 3/4 (101.6 x 70.5)

212. Baby Basilisk, 1991
Clay, acrylic, beads, rhinestones on hubcap
diam. 16 1/2 (41.9)

213. Baroque Hubcap, 1991
Plaster, acrylic, oil, glitter on hubcap
diam. 15 1/2 (39.4)

214. Briefcase, 1991
Acrylic, enamel, copper wire, leather briefcase
16 1/2 x 16 3/4 x 4 1/2
(41.9 x 42.6 x 11.4), with handle

215. Crouched Like That for Days Then Moved On, 1991
Mixed media
9 7/8 x 9 3/8 x (l.) 16 1/2
(25.1 x 23.9 x [l.] 41.9)

216. The Fall of Icarus, 1991
Oil, enamel, acrylic, beads on cabinet door
19 3/8 x 54 1/8
(49.2 x 137.5)

217. Gog & Magog, 1991
Bottle, light bulb, mixed media
11 1/2 x 7 x (l.) 14 1/4
(29.2 x 17.8 x [l.] 36.2)

218. Hubcap Sculpture, 1991
Clay, acrylic, beads, cardboard on wheel rim
diam. 15 1/4 (38.7)

219. I Had to Put on the Shoes of the Gospel, 1991
Box, shoes, bottles, books, mixed media
22 x 27 3/4 x 17
(55.9 x 70.5 x 43.2)

220. King Orth, 1991
Oil, acrylic, beads on found framed map
47 x 36 7/8 (119.4 x 93.7)

221. King Orth Wheel of Life, 1991
Plaster, acrylic, oil, beads, feathers, plastic hubcap
diam. 17 1/4 (43.8)

222. Red King Orth, 1991
Acrylic, plaster, cardboard on hubcap
diam. 15 1/2 (39.4)

223. Sun Face, 1991
Clay, acrylic, beads, rhinestones on hubcap
diam. 15 1/4 (38.7)

224. Visionary Hubcap, 1991
Wheel rim plaster, acrylic, felt-tip marker, cardboard
diam. 14 1/2 (36.8)
Lent by Mr. Imagination, Chicago

225. Visionary Hubcap, 1991
Wheel rim, plywood, clay, paint
diam. 16 (40.6)

226. Visionary Mirror, 1991
Mirror, mixed media
45 x 20 (114.3 x 50.8)

227. Alpha & Omega, 1992
Acrylic on canvasboard, beads, rhinestones, on cabinet door
27 3/4 x 13 7/8
(70.5 x 35.2)

228. **The Basilisk,** 1992
Clay, beads, rhinestones,
acrylic on hubcap
diam. 16 1/4 (41.3)

229. **Brown Thrasher,**
1992
Oil, enamel on plywood
25 3/16 x 30 3/8
(65.3 x 77.2)

230. **By the Rivers of
Babylon,** 1992
Oil, enamel on plywood
31 1/2 x 40 3/4
(80 x 103.5)

231. **Deep Calls to Deep,**
1992
Oil, acrylic on window
40 1/8 x 25 13/16
(101.9 x 65.6)

232. **Diamonda,** 1992
Bottles, mixed media
19 1/2 (49.5)
Lent by David Berube,
Chicago

233. **Dreadnaught,** 1992
Oil, enamel on
cabinet door
24 x 36 1/2 (61 x 92.7)

234. **Ezekiel,** 1992
Plaster, acrylic,
beads on drawer piece
18 5/8 x 10 5/8 (47.3 x 27)

235. **Found Object
Sculpture,** 1992
Concrete, baby food jars,
gasoline can, hubcap
24 (61)

236. **Glory Road,** 1992
Plaster, acrylic, beads,
rhinestones on hubcap
diam. 15 1/4 (38.7)

237. **Glory Time,** 1992
Plaster, acrylic, beads
on plastic hubcap
diam. 16 1/2 (41.9)

238. **Jester with Purple
Hat,** 1992
Bottles, mixed media
14 3/4 (37.5)
Private collection,
Chicago

239. **King of Rap,** 1992
Bottles, book,
mixed media
11 1/4 x 8 x 5 1/4
(28.6 x 20.3 x 13.3)
Private collection,
Chicago

240. **The Master
Scavenger, King
Orth,** 1992
Enamel housepaint,
felt-tip marker, mixed
media on masonite
24 5/8 x 16 7/8
(62.6 x 42.9)
Lent by Mr. and Mrs.
Michael F. McCartin,
Chicago

241. **Mr. D,** 1992
Bottle, jars, book,
mixed media
24 1/4 x 8 3/8 x 5 3/4
(61.6 x 21.3 x 14.6)
Private collection,
Chicago

242. **Oh My Girl, Heart's
Desire,** 1992
Felt-tip marker
on cardboard
Eight panels,
each 16 1/4 x 10 3/8
(41.3 x 26.4)

243. **Sparkle,** 1992
Oil, enamel on window
35 1/4 x 29 1/4
(89.5 x 74.3)

244. **Spirit Painting,** 1992
Window, masonite,
beads, paint
33 1/8 x 17 7/8
(84.1 x 45.4)

245. **Twin Abstract
Cathedral Windows,**
1992
Oil, acrylic on windows
Each panel 37 3/4 x
30 15/16 (95.9 x 78.6)

246. **Voodoo Child,** 1992
Oil, enamel on window
28 7/8 x 48 (73.3 x 121.9)

247. **Window Painting,**
1992
Oil, enamel on window
33 3/4 x 26 7/8
(85.7 x 68.3)

248. **Wine Was Strewn
Across the Field,**
1992
Bottles, mixed media
19 3/8 x 16 7/8 x 5 3/4
(49.2 x 42.9 x 14.6)

249. **Glory Time,** 1992-93
Oil, acrylic on window
35 1/8 x 29 1/4
(89.2 x 74.3)

250. **Hubcap Sculpture,**
1992-93
Wheel rim, found objects,
glitter, acrylic, concrete
diam. 14 1/4 (36.2)

251. **Ancestry,** 1993
Oil, enamel, acrylic,
beads, concrete on
cabinet door
29 3/8 x 16 (74.6 x 40.6)

252. **Blissful Secret
Inside Neverending
Walk Forward
Alive Loving Every
Minute,** 1993
Wood, concrete, nails,
beads, acrylic
34 3/4 (87.6)

253. **Diva,** 1993
Bottle, mixed media
13 (33)
Browdell Collection,
Chicago

254. **Double Birth
(Majestic &
Neverending
Remembrance of
These Miracles),** 1993
Acrylic on plywood
20 3/4 x 40 3/8
(52.7 x 102.6)

255. **Dream Time All
Over Earth,** 1993
Concrete, acrylic, beads,
rhinestones on hubcap
diam. 16 1/2 (41.9)

256. **Grace,** 1993
Clay, acrylic, oil, enamel,
beads on found
framed print
19 5/8 x 15 (49.9 x 38.1)

257. **The Great Excelsior
Flys** [sic], 1993
Bottle, book,
mixed media
19 1/4 x 9 1/2 x 6 1/4
(48.9 x 24.1 x 15.9)
Private collection,
Chicago

258. **Handprint Fortune-
Telling Table,** 1993
Window, masonite,
acrylic, beads
25 3/4 x 28 5/8
(65.4 x 72.7)

259. **King Orthy's
Cathedral of the
Dreams,** 1993
Concrete, wood, nails,
beads, paint
34 3/4 (88.3)

260. **King Orthy's
Cathedral of the
Dreams,** 1993
Enamel, acrylic
on window
16 1/8 x 22 1/8 (41 x 56.2)

261. **Love from King
Orthy's Cathedral
of the Dreams,** 1993
Concrete, wood, nails,
beads, paint
41 1/2 (105.4)
Private collection,
Chicago

262. Music, 1993
Acrylic on plywood
35 7/8 x 23 (91.9 x 58.4)

263. Night Orchard, 1993
Oil on window
21 1/8 x 25 5/8
(53.7 x 65.1)
Browdell Collection,
Chicago

**264. Night Spirit in the
Forest,** 1993
Oil, acrylic on plywood
15 1/8 x 17 7/8
(38.4 x 45.4)

265. Sun Face, 1993
Concrete, oil, acrylic,
beads on hubcap
diam. 16 1/4 (41.3)

**266. Three Visionary
Heads,** 1993
Oil, enamel on window
32 x 25 3/4 (81.3 x 65.4)

267. Voodoo Cane, 1993
Concrete, acrylic,
rhinestones, varnish
on stick
37 (94)

**268. Walk with Faith Day
and Night,** 1993
Concrete, wood, nails,
beads, acrylic
34 5/8 (88)

**269. White Concrete
Face,** 1993
Found objects, enamel,
concrete
9 3/8 x 6 (23.9 x 15.2)

270. Amore, n.d.
Bottles, light bulb,
mixed media
14 1/4 (36.2)
Private collection,
Chicago

271. Confidential, n.d.
Bottles, book,
mixed media
25 1/2 x 7 3/4 x 5 1/4
(64.8 x 19.7 x 13.3)
Private collection,
Chicago

272. Dr. Faustus, n.d.
Bottles, book, can,
mixed media
12 x 8 1/2 x 5 3/4
(30.5 x 21.6 x 14.6)
Private collection,
Chicago

273. Dreadnaught, n.d.
Oil on cardboard
mounted on wood
11 1/8 x 15 5/8
(28.3 x 39.7)
Lent by John and Laima
Hood, New York

**274. Jim Beam on a
Book,** n.d.
Bottle, book,
mixed media
12 x 7 3/4 x 5 1/4
(30.5 x 19.7 x 13.3)
Lent by David Berube,
Chicago

275. The Magic Hour, n.d.
Bottle, light bulb,
mixed media
16 3/4 (42.6)
Private collection,
Chicago

276. Misterioso, n.d.
Bottles, mixed media
15 (38.1)
Private collection,
Chicago

277. Self-Portrait, n.d.
Oil on window
25 x 58 1/4 (63.5 x 148)
Private collection,
Chicago

278. Splendor, n.d.
Bottle, book,
mixed media
17 3/4 (45.1)
Browdell Collection,
Chicago